Sept 2006

Mike,
I hope you enjoy the
beauty of Yellowstone through my
vision,
Dave Dahser

PORTRAIT OF YELLOWSTONE

LAND OF GEYSERS & GRIZZLIES

photography by
David William Peterson

FARCOUNTRY
PRESS

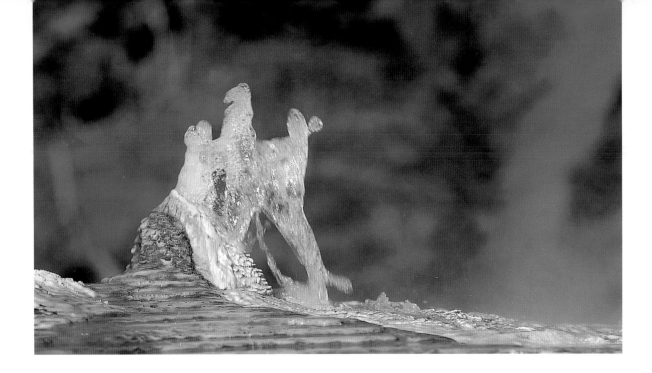

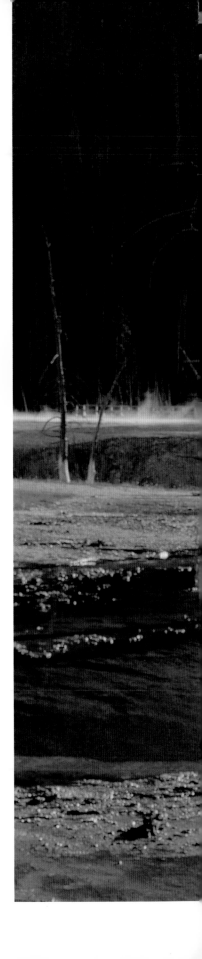

Above: Water bubbles up from an unnamed hot spring, stained yellow with bacterial growth.

Right: These trees along Iron Creek, Black Sand Basin, were killed by the thermal waters and the intake of silica.

Title page: Sapphire Pool in Biscuit Basin, which is named for the biscuit-shaped formations that surround the brilliant blue pool.

Front cover: Visitors stroll the boardwalk along Grand Prismatic Spring, the largest hot spring in the United States, and the third largest in the world. It is 250 feet by 370 feet and emerges from a mound surrounded by steplike terraces.

Back cover, clockwise: A young grizzly wanders through deadfall; Lone Star Geyser; grizzly sow and cubs; Giant Geyser.

Front flap: The Firehole River flows through Midway Geyser Basin.

ISBN 13: 978-1-56037-383-4
ISBN 10: 1-56037-383-0
Photographs © 2006 David William Peterson
© 2006 Farcountry Press

For more information about our books write Farcountry Press, P.O. Box 5630,
Helena, MT 59604; call (800) 821-3874; or visit www.farcountrypress.com.

Created, produced, and designed in the United States.
Printed in Korea.

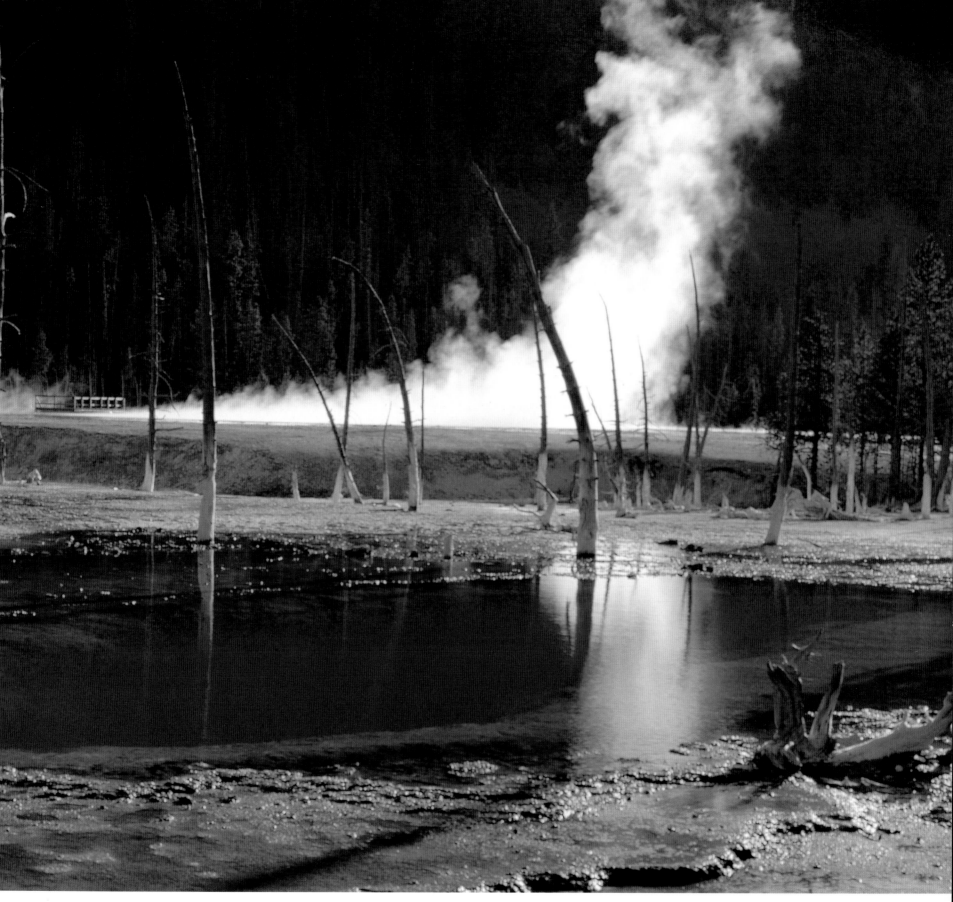

Right: Old Faithful Geyser, a symbol of Yellowstone National Park, features dramatic eruptions every 45 to 120 minutes.

Facing page: Lodgepole pine trees, which were killed by the thermal waters, have become known as "bobby sock trees" because of their "socks" of white silica.

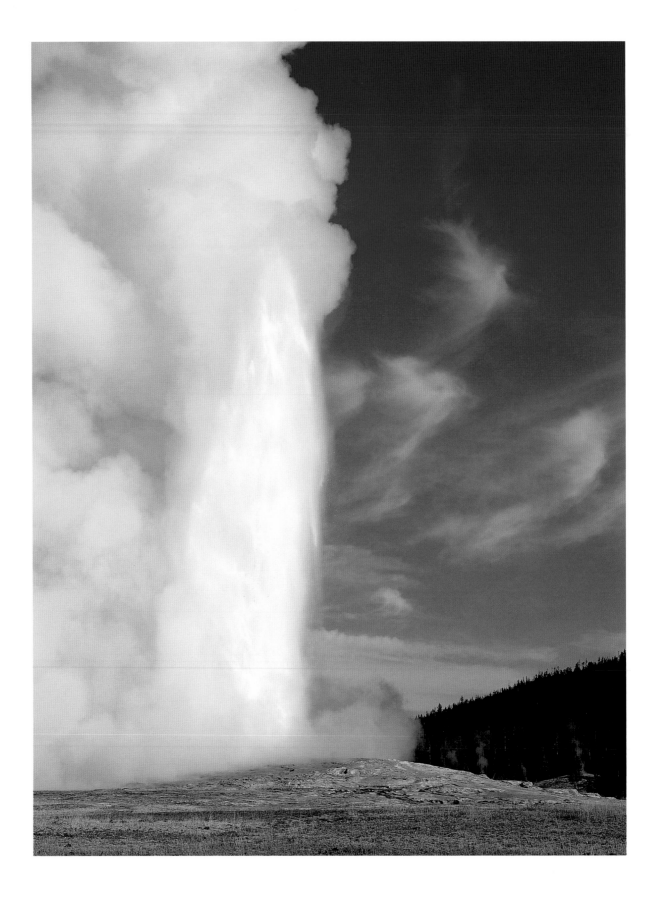

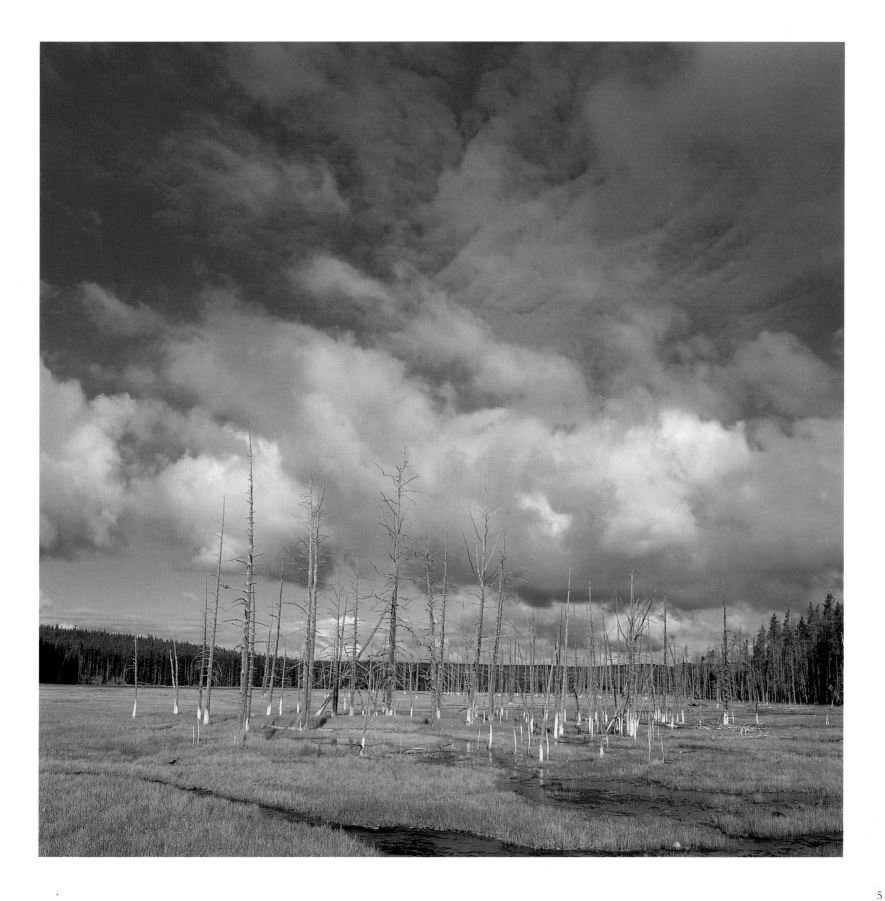

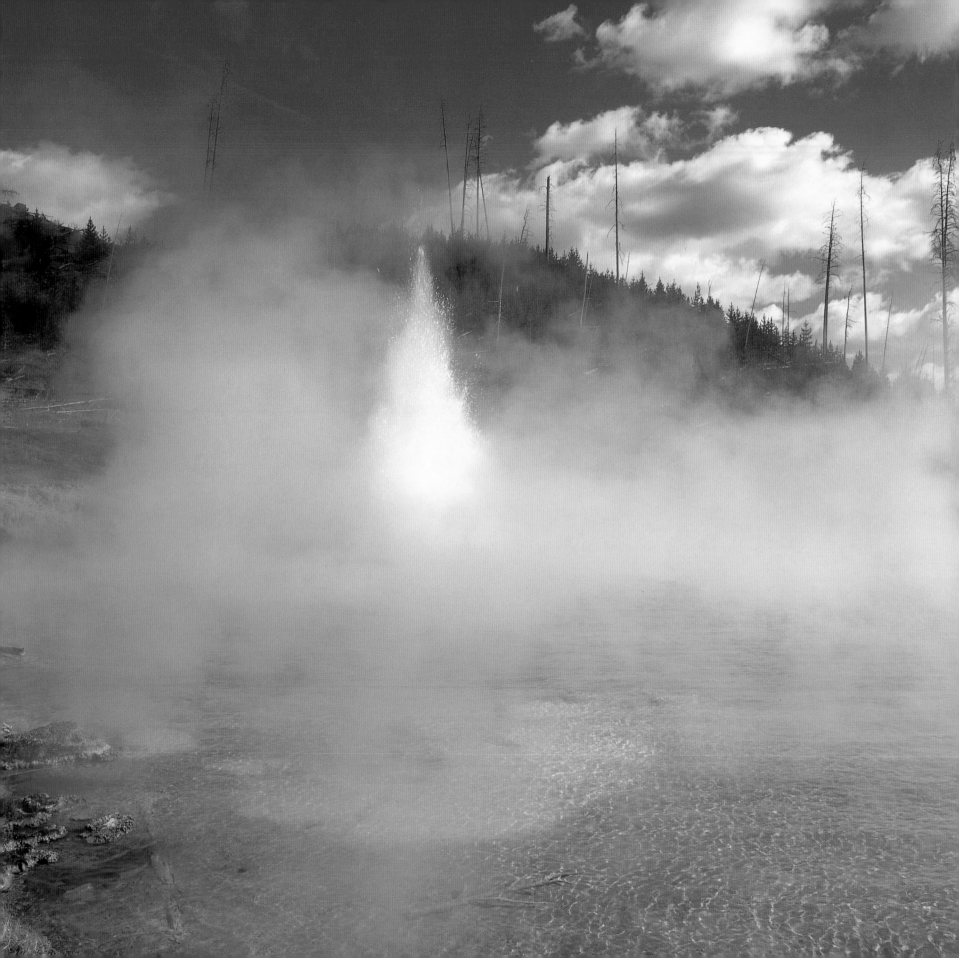

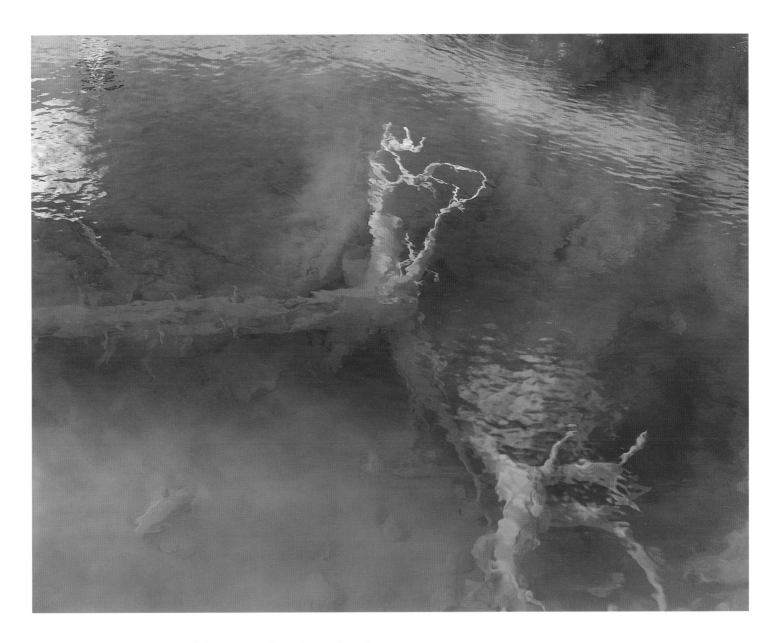

Above: The deep-blue waters of a hot spring along the Firehole River.

Facing page: Imperial Geyser was named as a result of a newspaper contest among journalists hosted by National Park Service founder and director Stephen Mather in 1929. When it is active, its eruptions can reach 50 feet.

Right: Two eagles perch above the Yellowstone River, searching for food.

Below: An early frost whitens the grasses and plants.

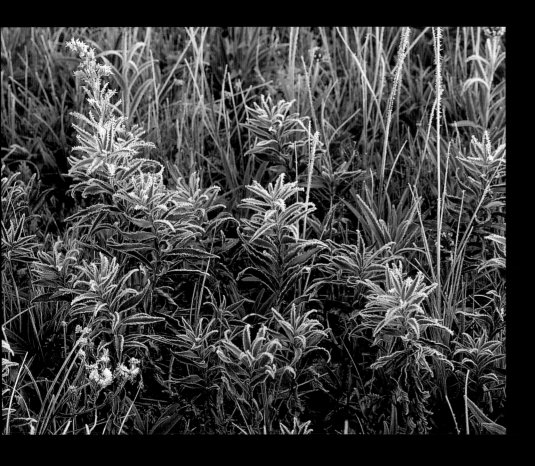

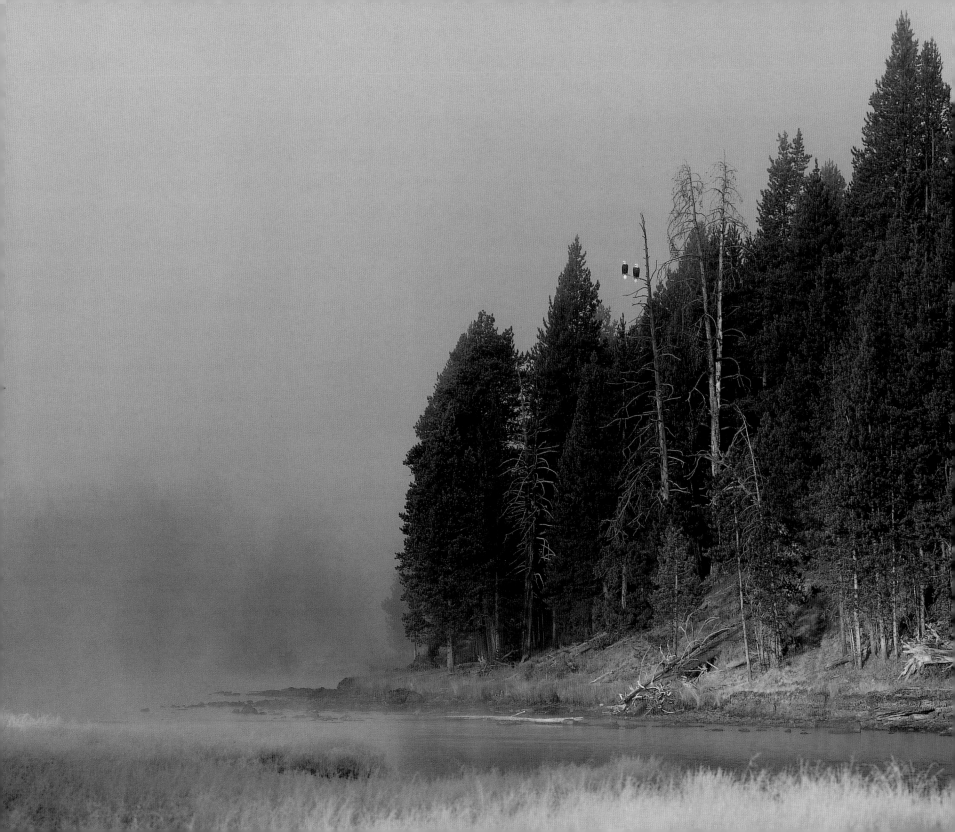

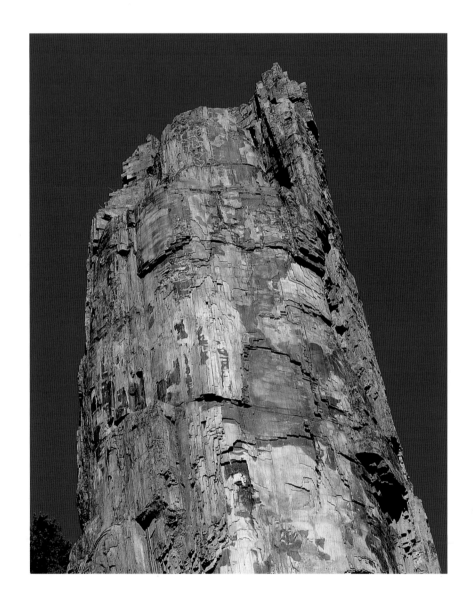

Above: The Petrified Tree, located in the Tower area, is a fossilized redwood approximately 50 million years old.

Right: The Little Firehole River becomes Mystic Falls as it drops 70 feet into the Firehole River Valley.

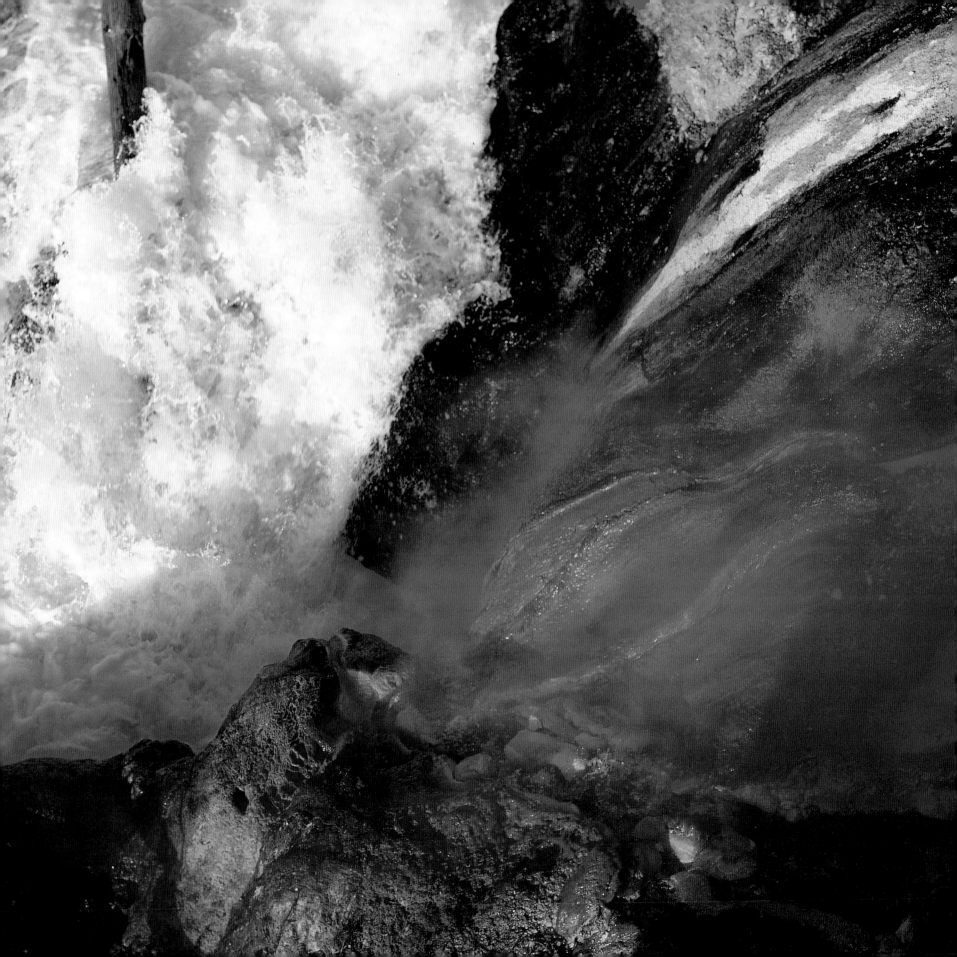

Right: A delicate spider web among the branches of a lodgepole pine tree.

Facing page: Known as Tomato Soup Spring, this is just one of Yellowstone National Park's 10,000 thermal features, which include brilliantly colored hot springs, bubbling mud pots, and steaming fumaroles.

Below: Scarlet Indian paintbrush and yellow sulfur buckwheat bloom on the flanks of the 10,243-foot Mount Washburn, which was named for the leader of the 1870 Washburn-Langford-Doane Expedition.

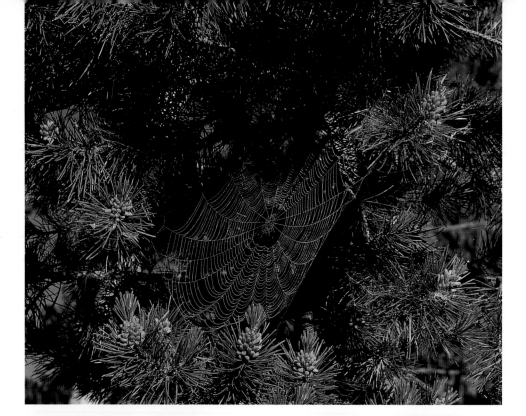

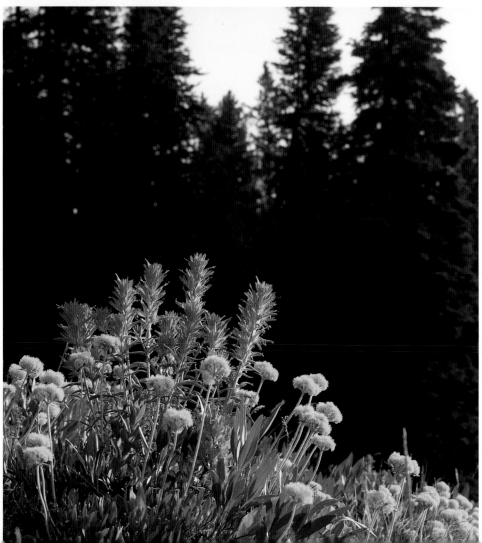

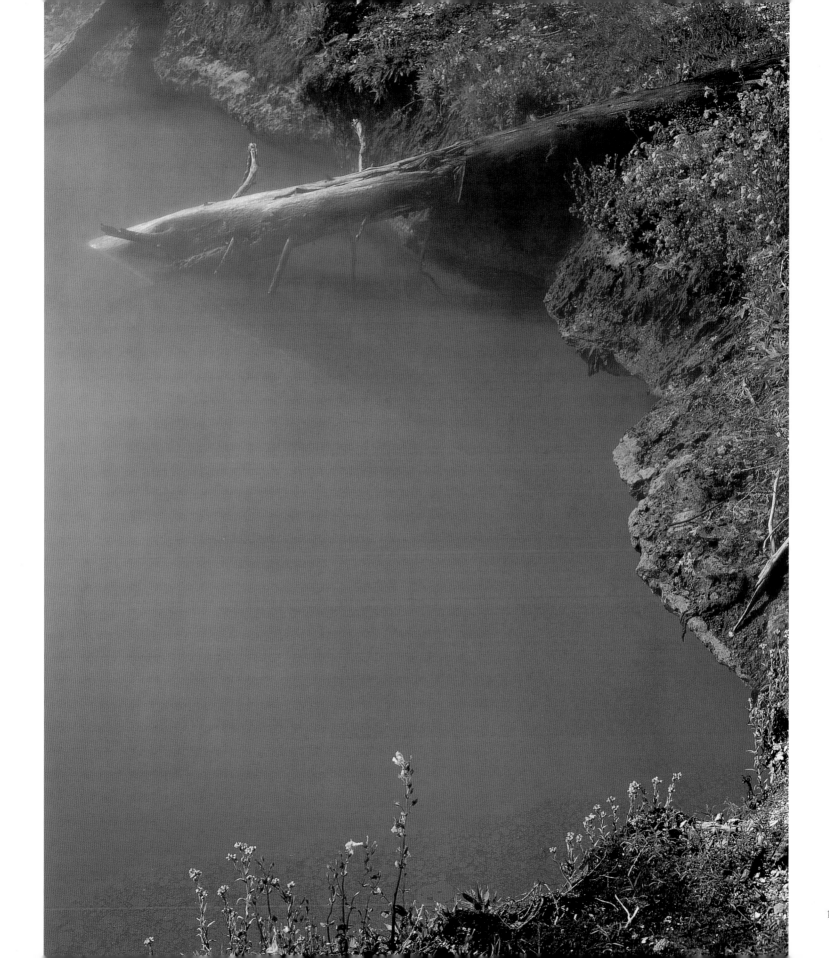

Facing page: A Douglas-fir leans out over the sapphire waters of Buck Lake in the Absaroka Range, in the northeastern section of the park.

Below: Let sleeping bison lie. Usually docile, bison are dangerous when approached.

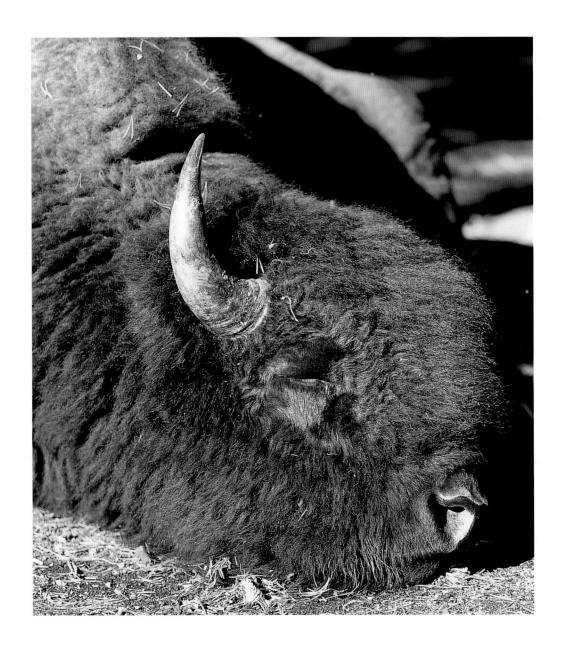

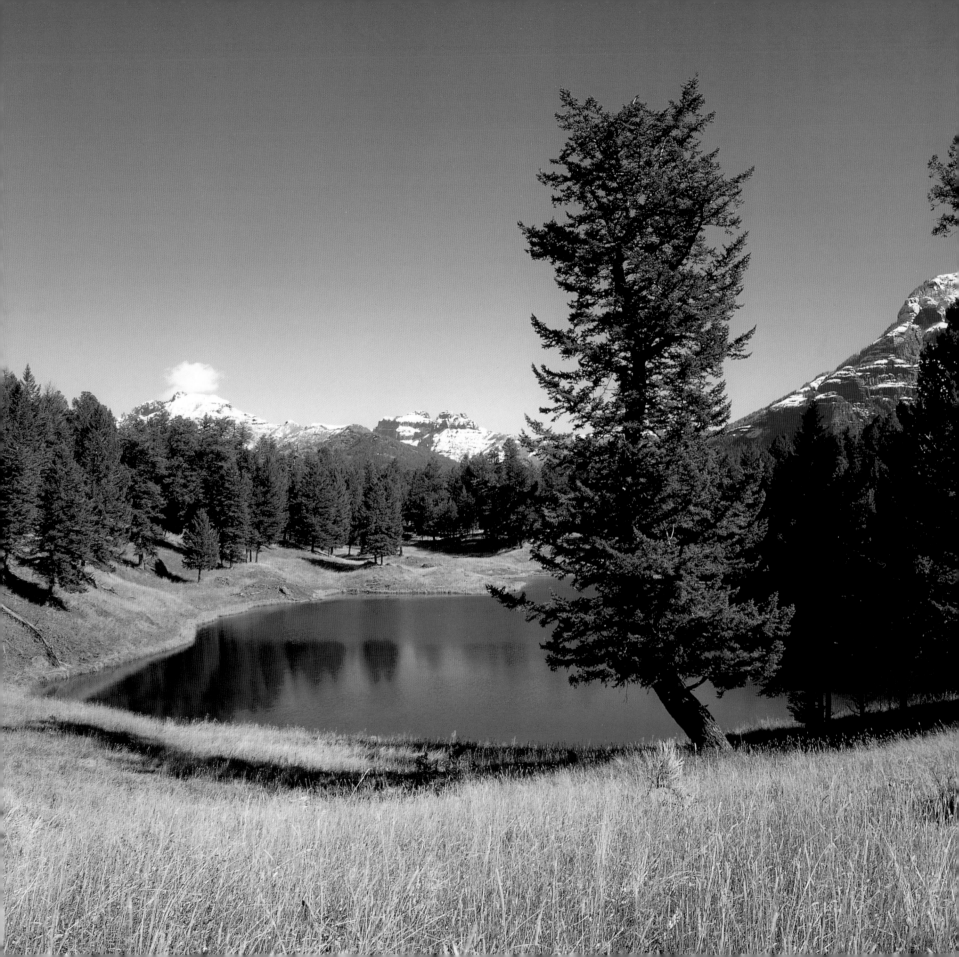

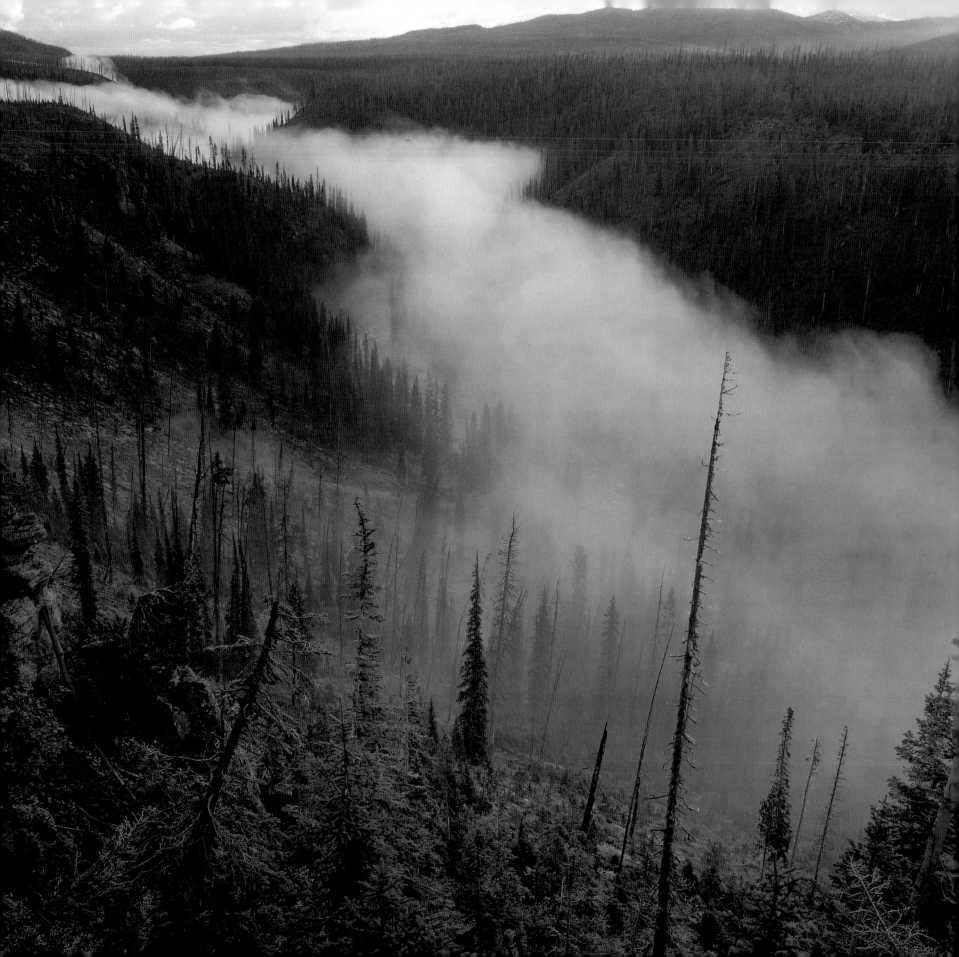

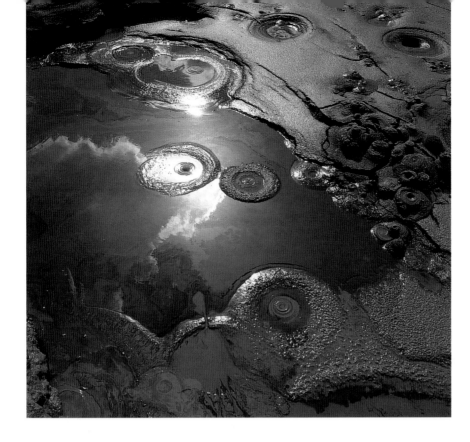

Left: Mud pots bubble in the park's Forest Springs area.

Facing page: In Lewis Canyon, fog hovers over a hillside of burned conifers.

Below: Union Falls drops 250 feet and is found in the area of the park known as Cascade Corner.

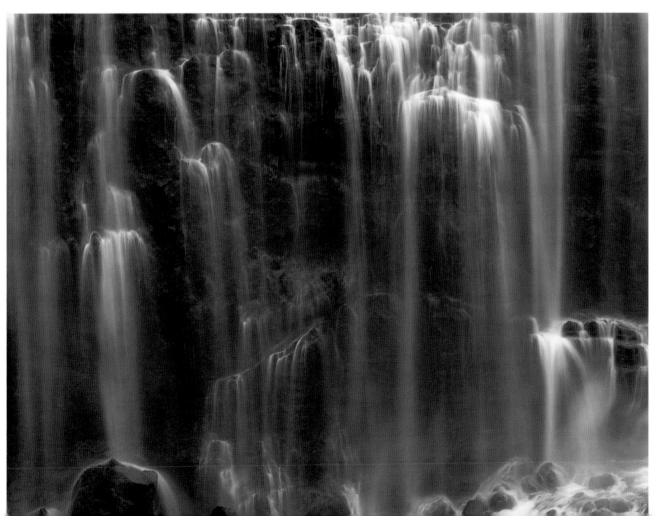

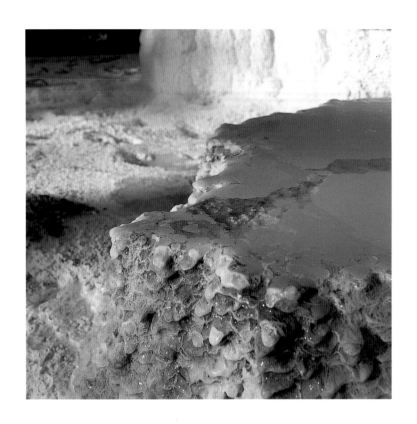

Left: A close-up of Mammoth's travertine terraces, which are formed as hot water rises through ancient limestone deposits.

Right: A field of monkeyflowers brightens the area around Firehole Lake, which isn't really a lake but a very large hot spring.

Below: A black bear cub gingerly walks along a fallen tree.

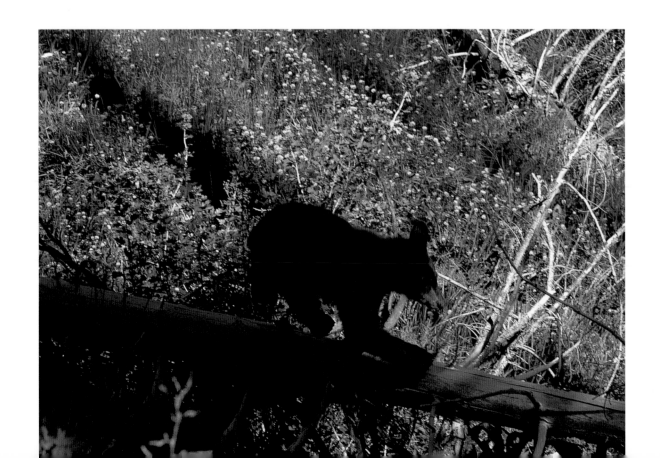

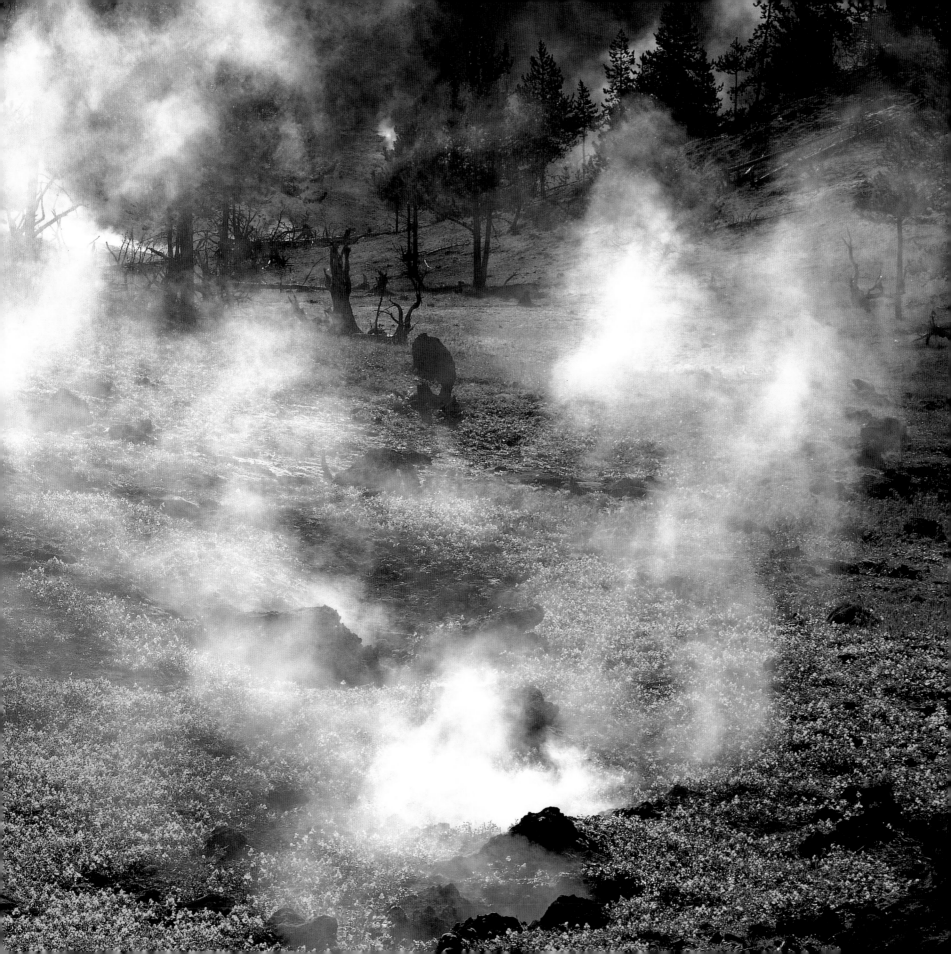

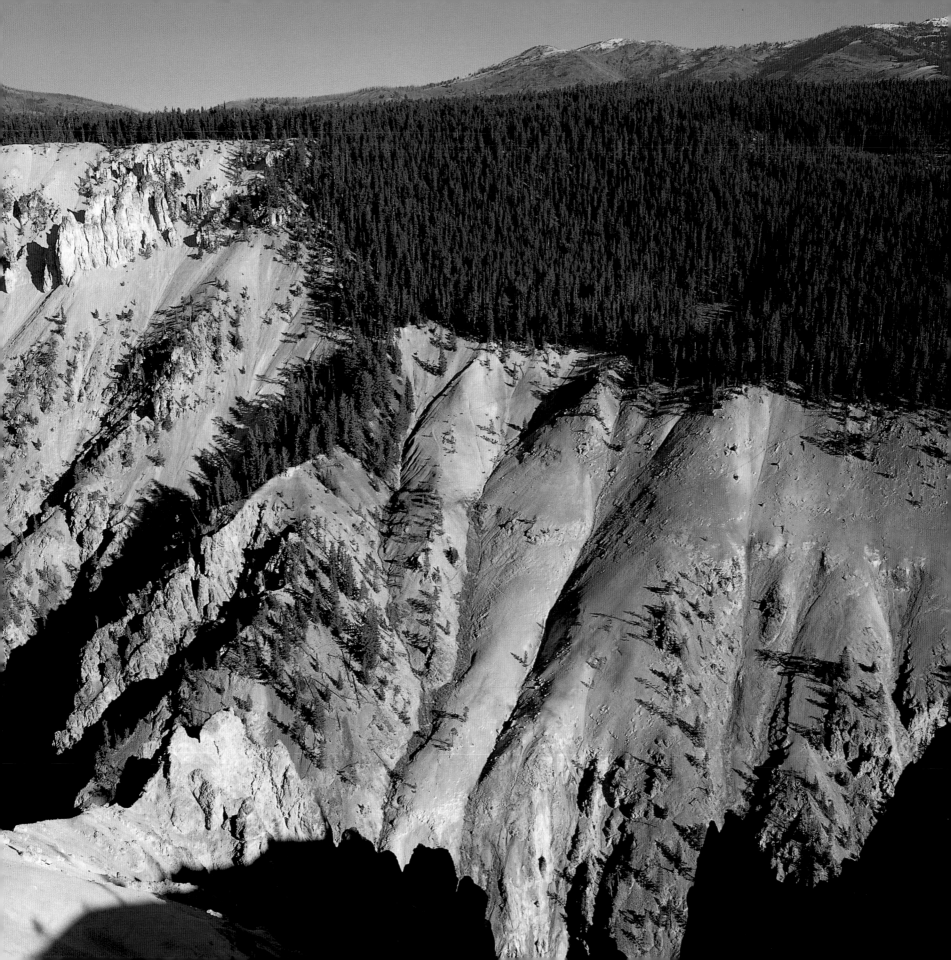

Left: The dramatic red-streaked Grand Canyon of the Yellowstone was created by volcanic and thermal activity and sculpted by ice, wind, and water.

Below: Alum Creek winds through Hayden Valley.

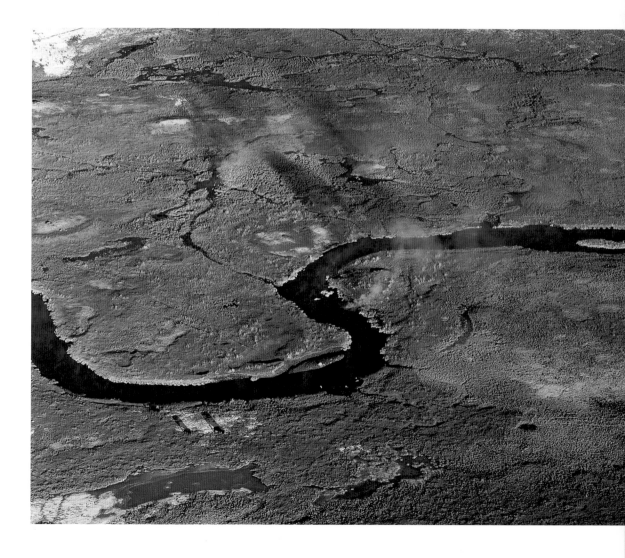

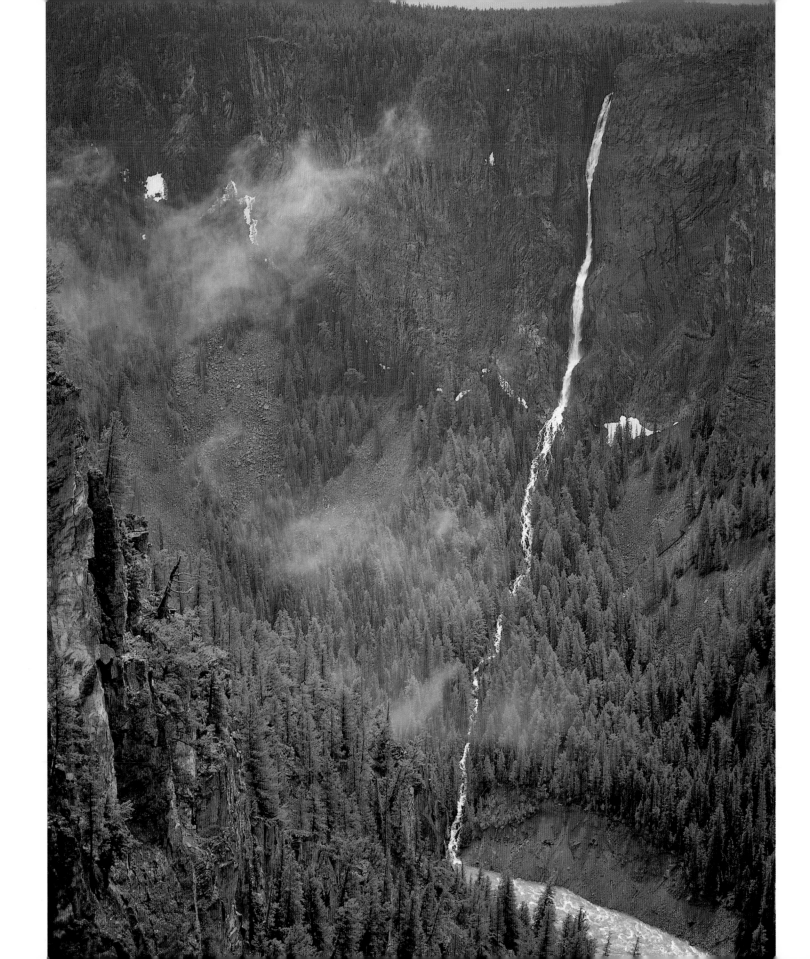

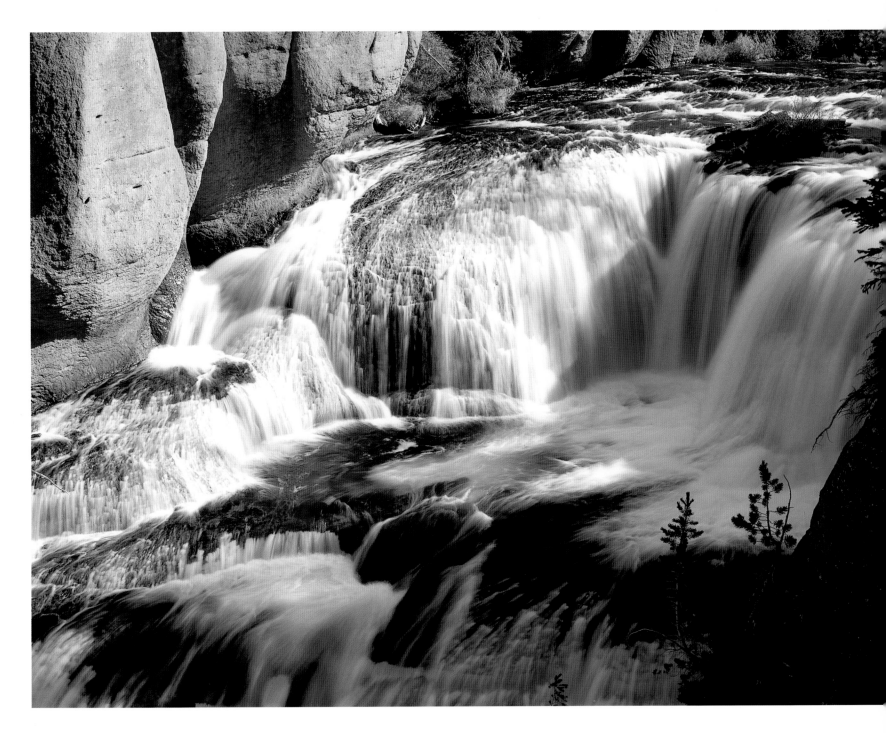

Above: Located in the southwestern part of the park, the Falls River Basin features numerous cascades and waterfalls.

Facing page: Surface Creek's Silver Cord Cascade plunges 1,200 feet to the Yellowstone River.

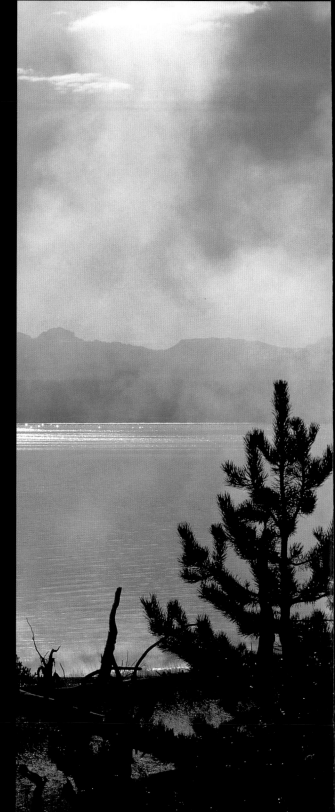

Right: An elk silhouetted in mist in West Thumb Geyser Basin along Yellowstone Lake.

Below: Sunlight filters through the branches of a lodgepole pine and the steam from a nearby geyser.

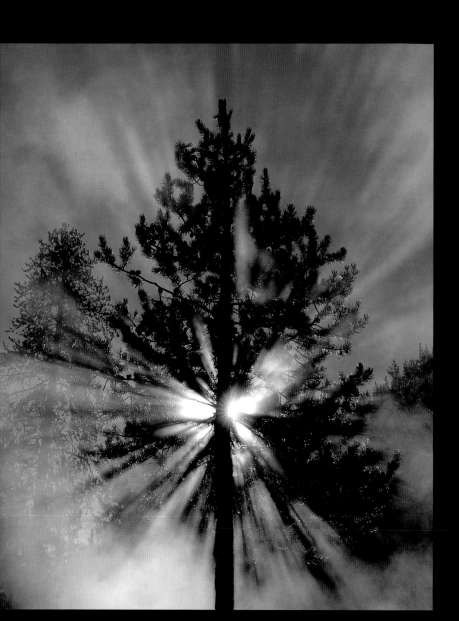

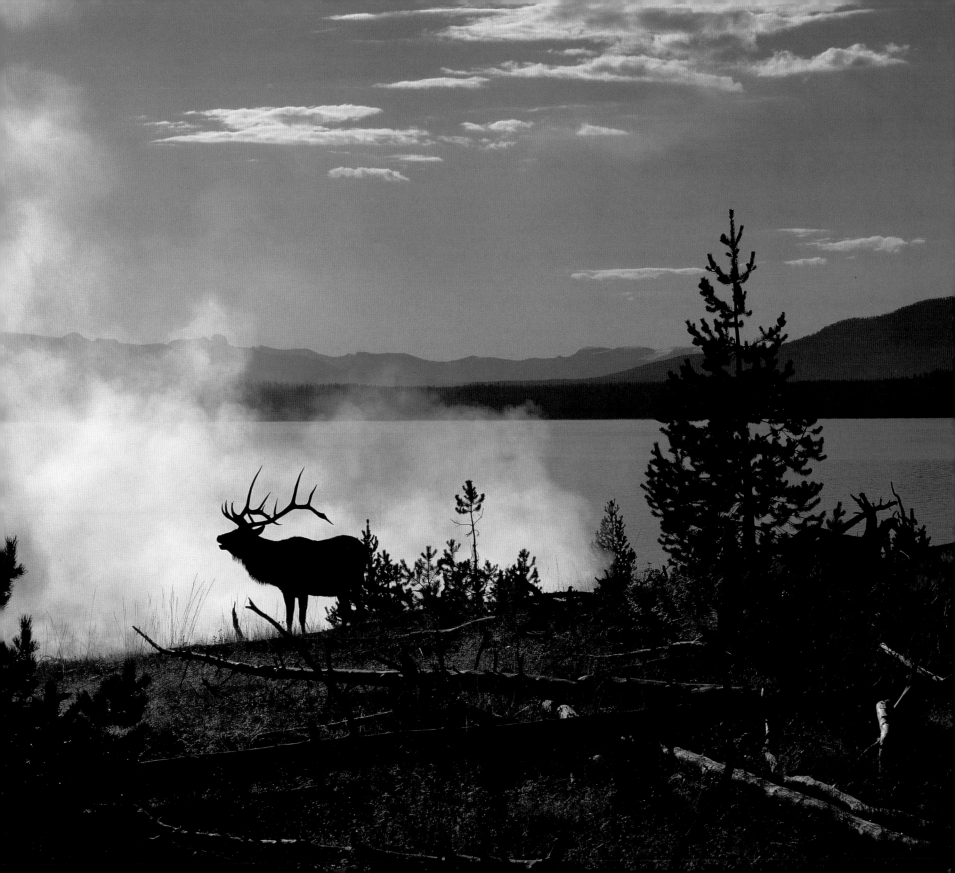

Left: These crusty biscuit formations at a backcountry pool are known as sinter or geyserite.

Below: Wildflowers are bright spots of color along the Firehole River.

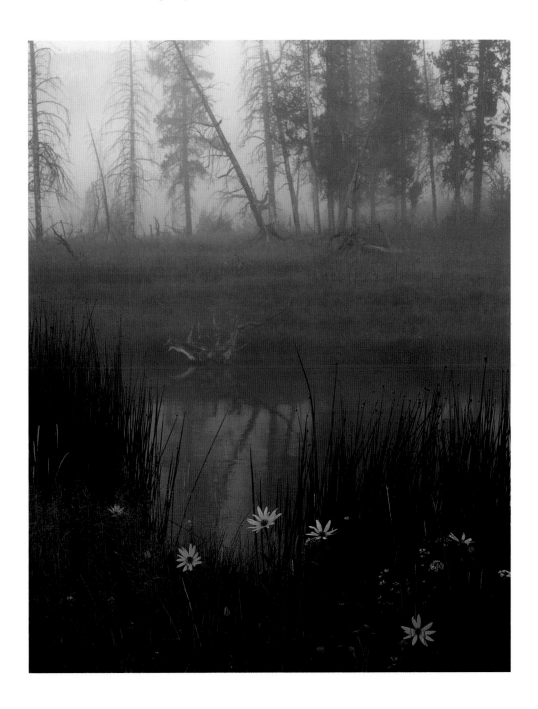

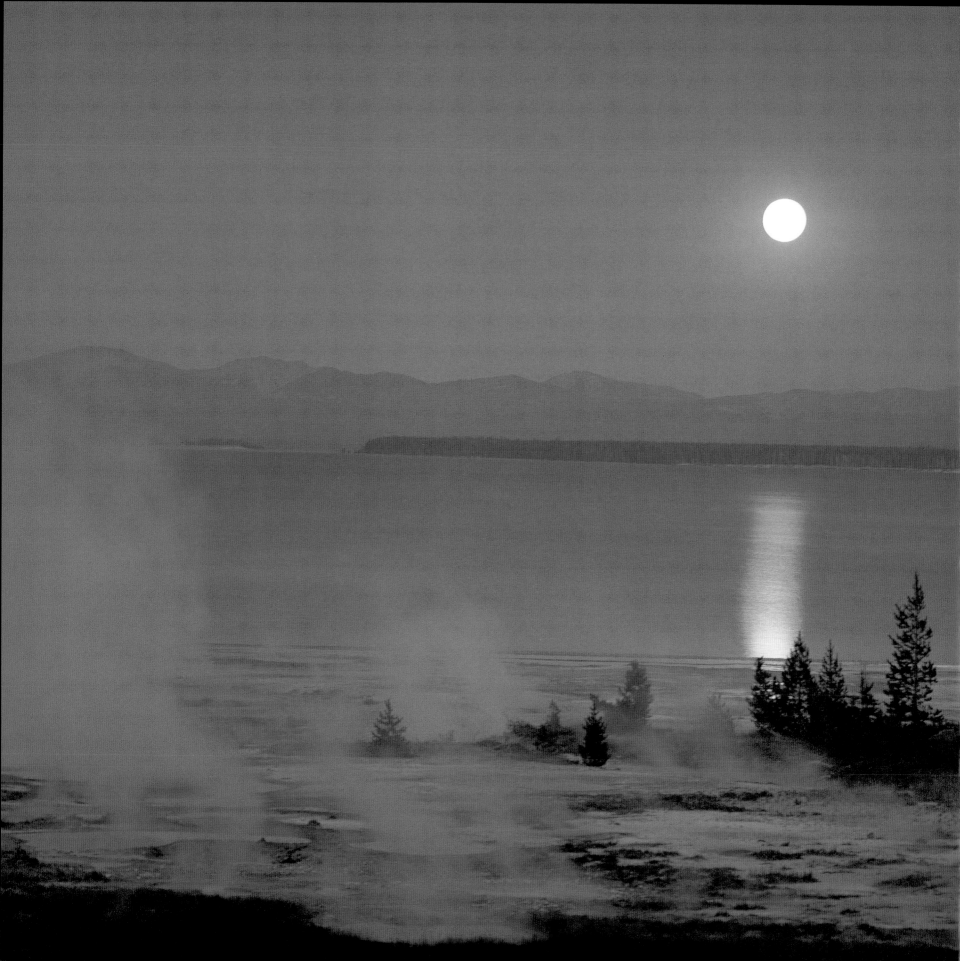

Left: The moon casts a path of yellow light along Yellowstone Lake, the largest natural freshwater lake above 7,000 feet in the United States.

Below: A lone bison is silhouetted against the blue waters of Yellowstone Lake and 10,308-foot Mount Sheridan.

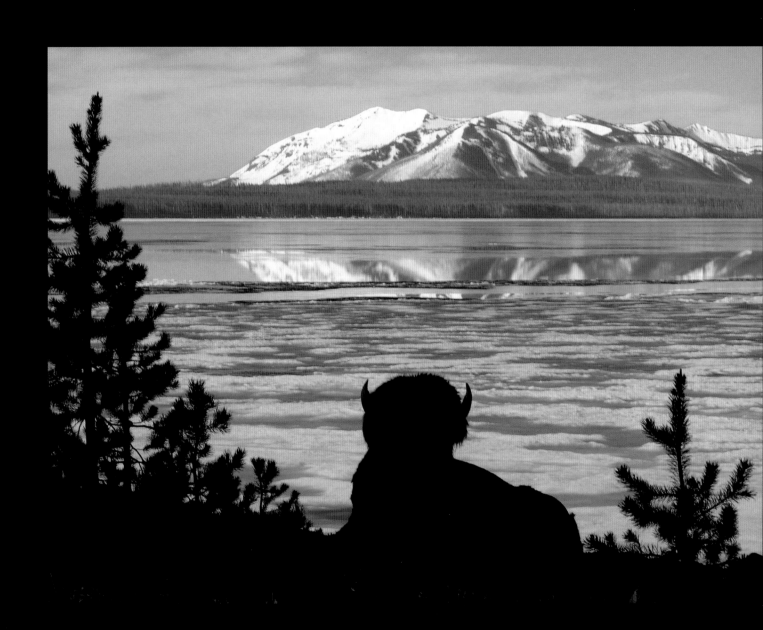

Facing page: Cocoa-colored Chocolate Pots lie along the Gibbon River.

Below: A moose dutifully watches over her calf near the Grand Canyon of the Yellowstone.

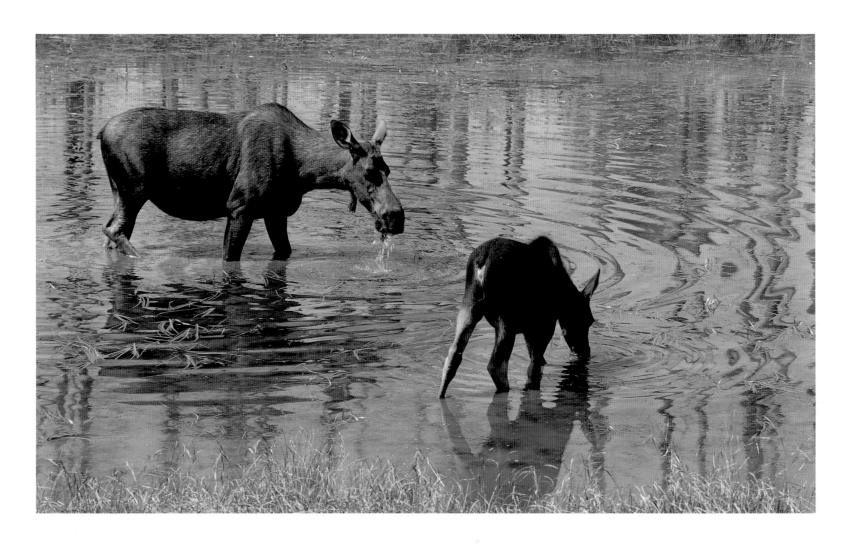

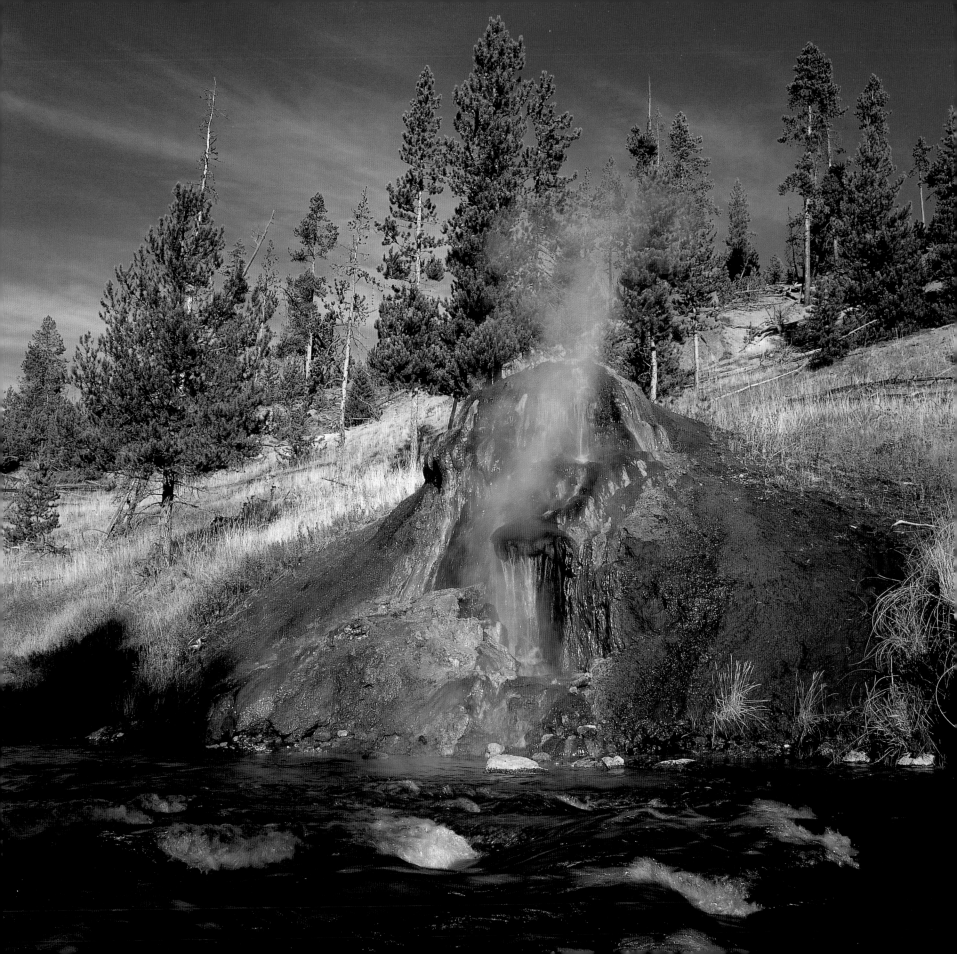

Right: A ghostly blue heron appears in mist along the Firehole River.

Below: This gently lapping water is shrouded in fog in the Norris Geyser Basin, the hottest and most changeable thermal area in Yellowstone National Park.

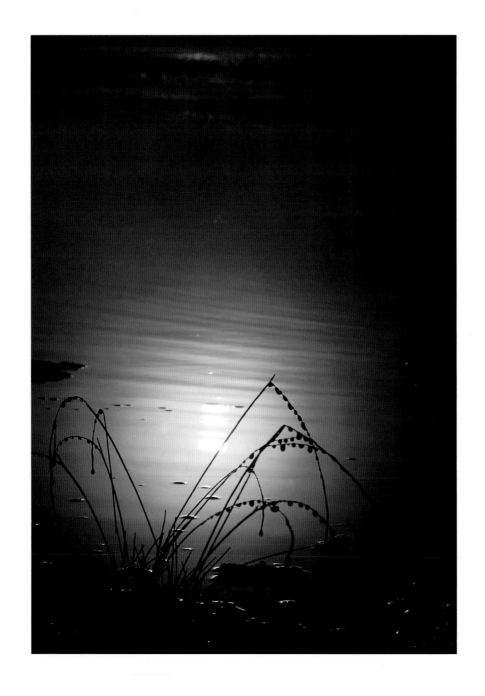

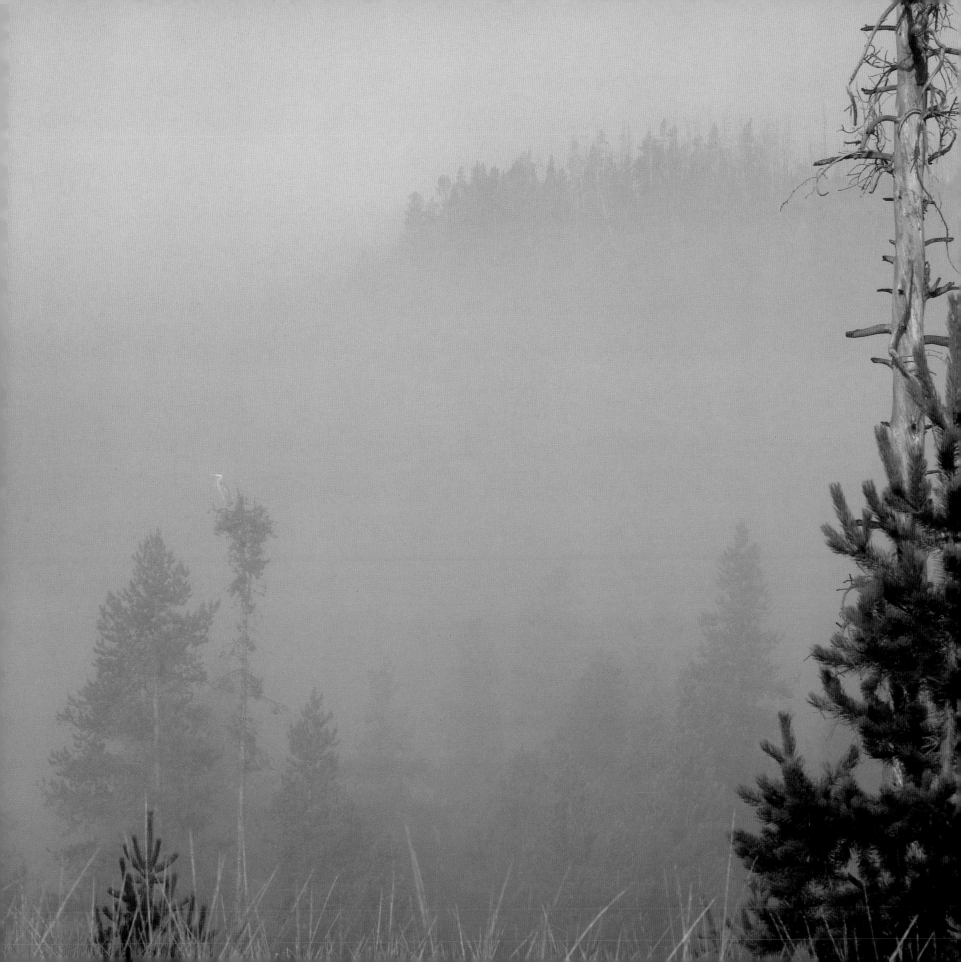

Right: In Black Sand Basin, Cliff Geyser erupts alongside Iron Spring Creek.

Below left: Spray Geyser is located in the 12-square-mile Lower Geyser Basin.

Below right: Sentinel Cone is one of the Lower Geyser Basin's numerous thermal features, which include geysers, mud pots, springs, and fumaroles.

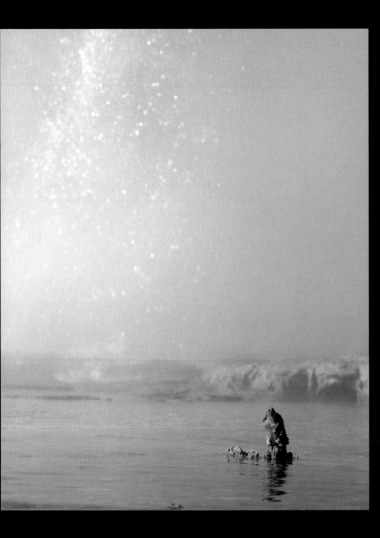

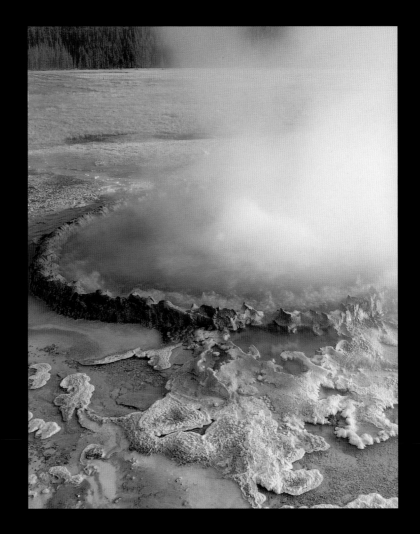

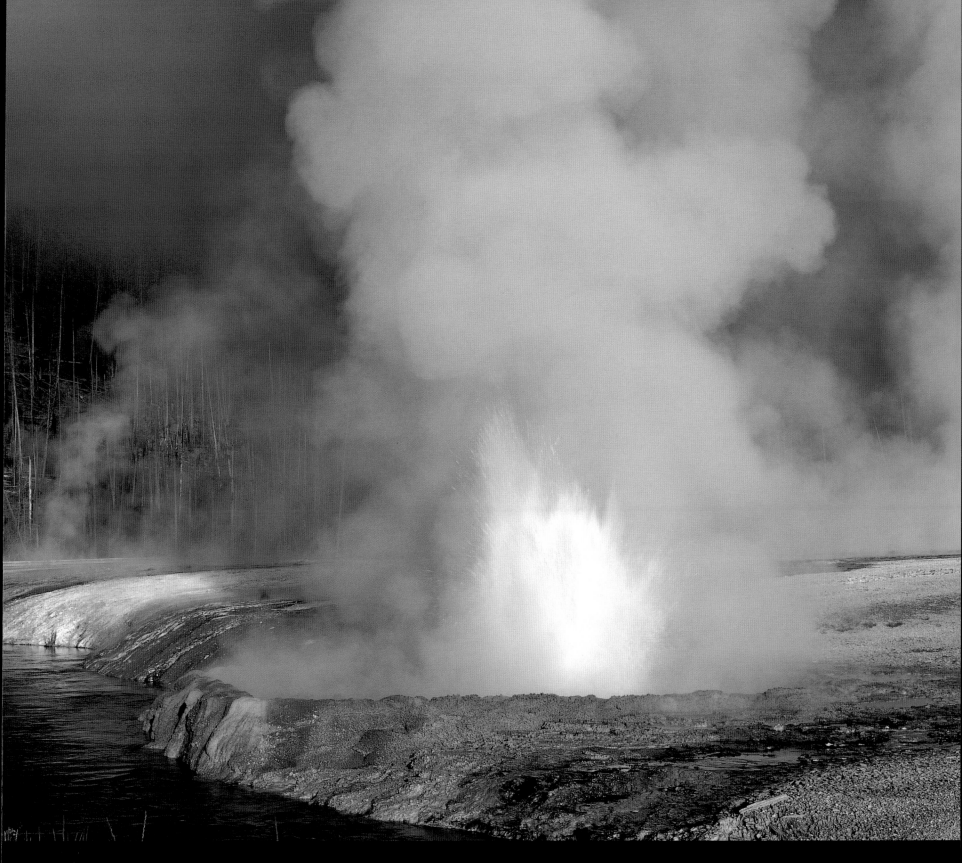

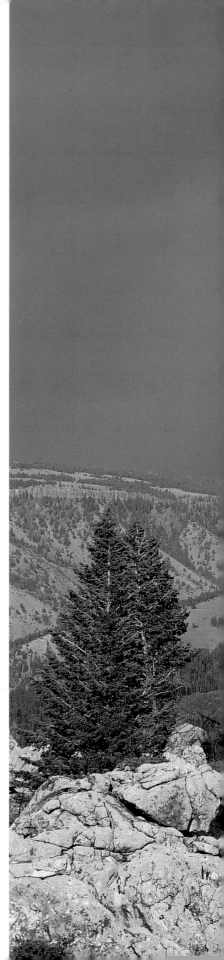

Right: In this view of the rugged northern part of the park, the base of Mount Everts appears at the left. The mountain was named after Truman Everts, who was found alive near Tower after 37 days of being separated from his party during the 1870 Washburn-Langford-Doane Expedition.

Below: Elk thistle, also known as Everts's thistle, saved the life of explorer Truman Everts, who subsisted on the raw root while separated from his group.

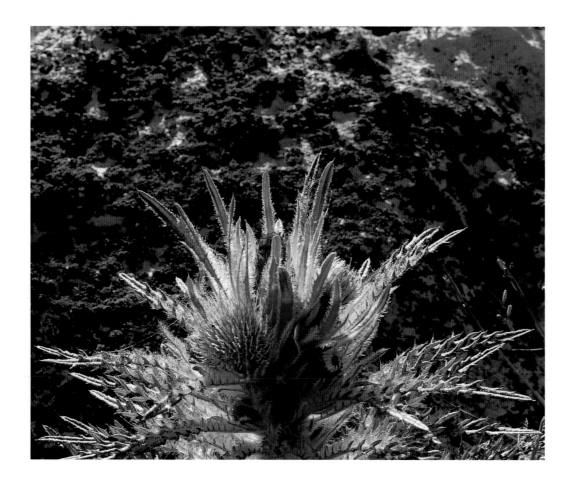

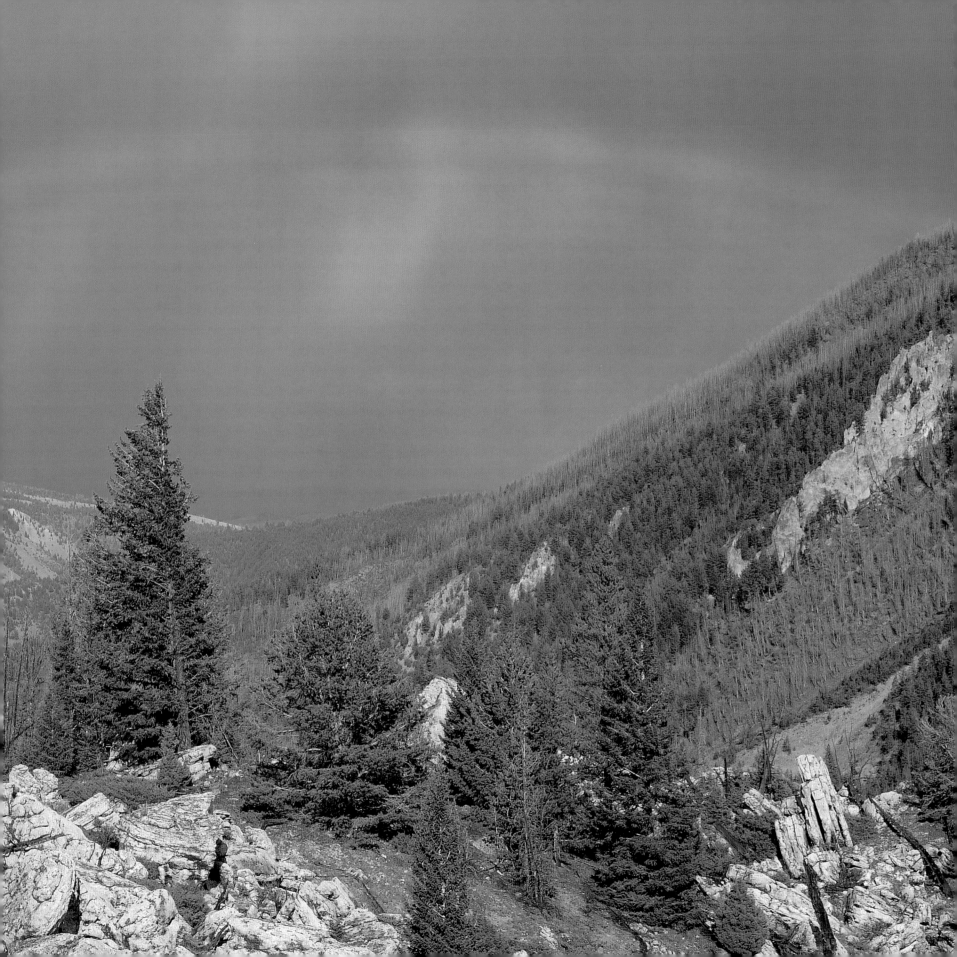

Right: A cow elk stands in the shadows of sunset-bathed Yellowstone Lake.

Below: A cone-type geyser, Lone Pine Geyser at West Thumb Geyser Basin features eruptions that reach heights of up to 75 feet.

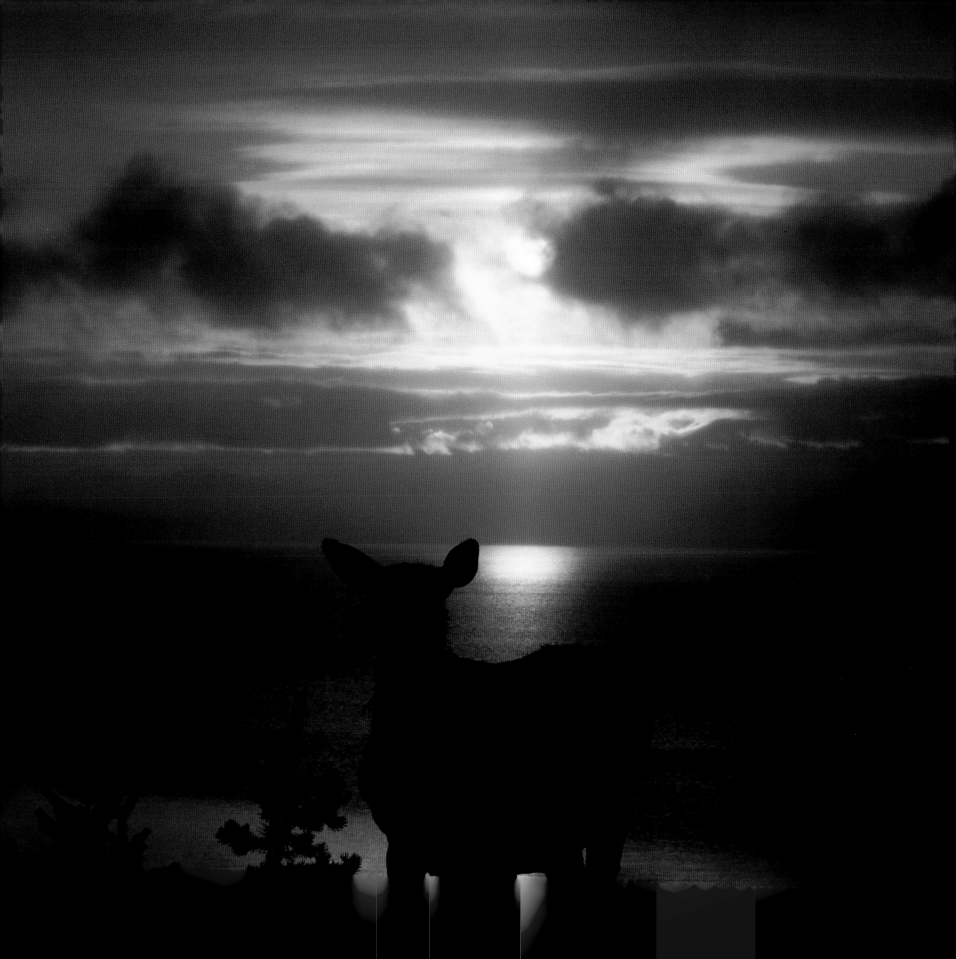

Right: Chilly scenes of winter at West Thumb Geyser Basin.

Below: Pocket Basin contains the largest collection of mud pots in Yellowstone National Park.

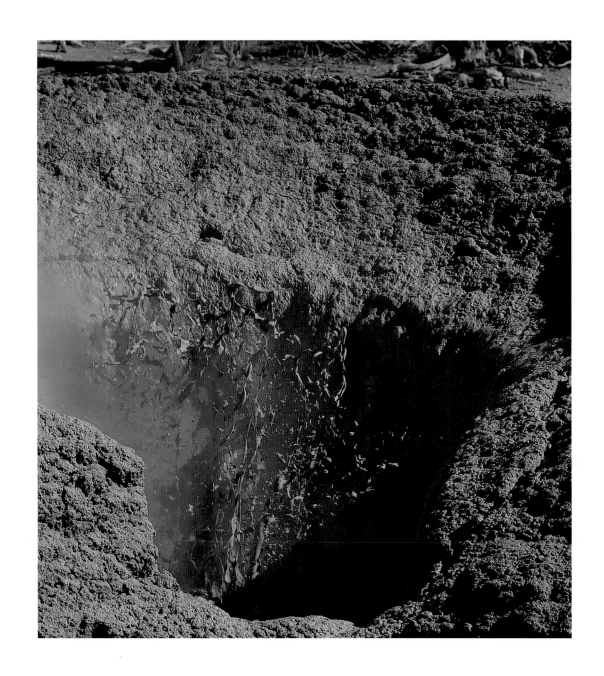

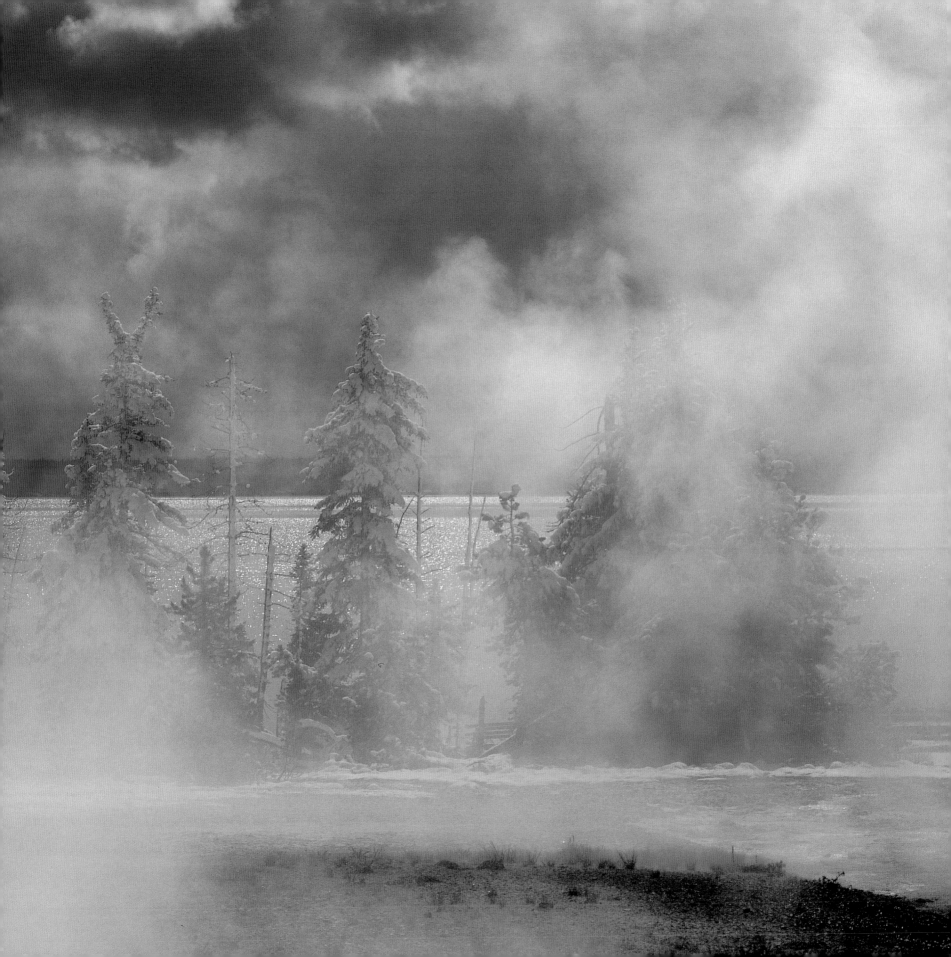

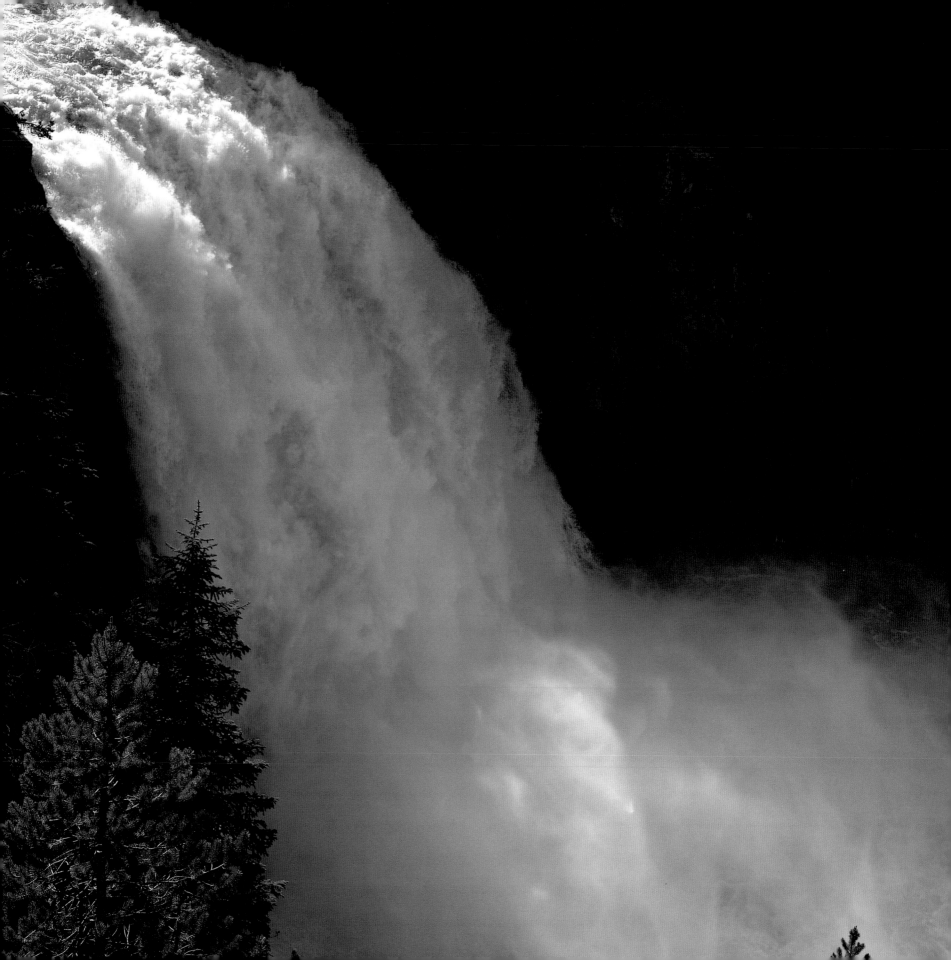

Left: The Upper Falls is a 109-foot waterfall on the Yellowstone River near Canyon Village.

Below: Intricate Rocky Mountain columbine, a wildflower that thrives in the moist, acidic soils of the rocky ledges, mountain meadows, and alpine slopes of Yellowstone National Park.

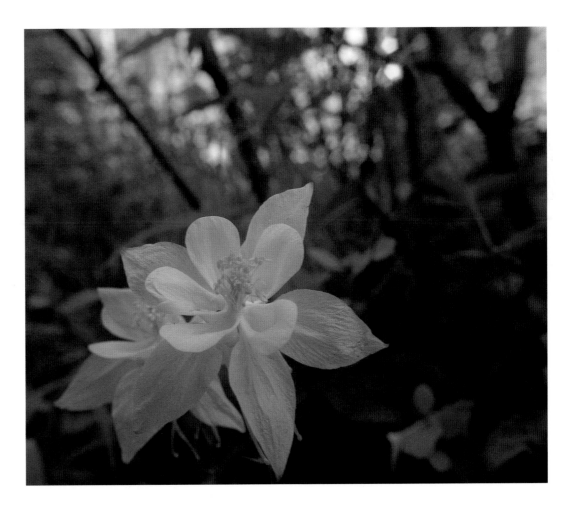

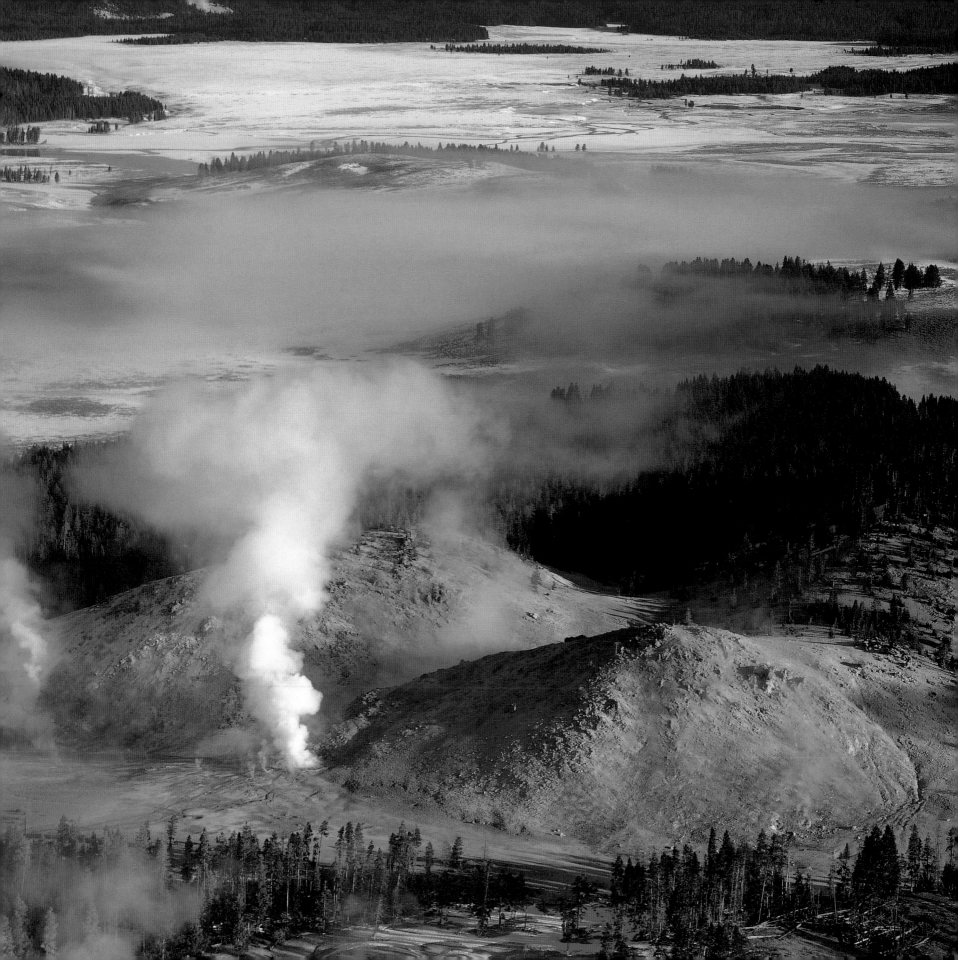

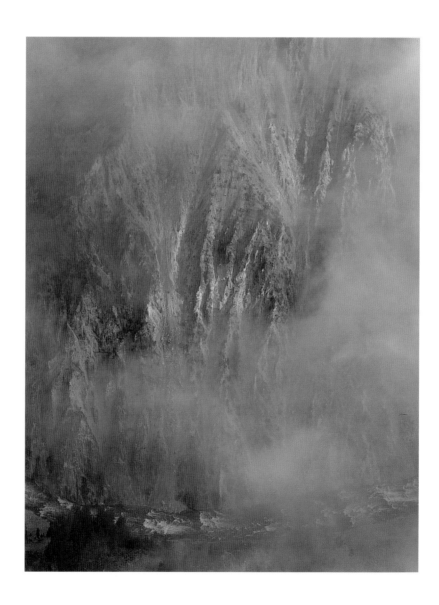

Left: The Grand Canyon of the Yellowstone, one of the park's most impressive features.

Far left: A sweeping vista of the Crater Hills thermal area in Hayden Valley.

Facing page: Daisy Geyser erupts at an angle for three to four minutes and reaches a height of 75 feet.

Below: Bison cross the Yellowstone River.

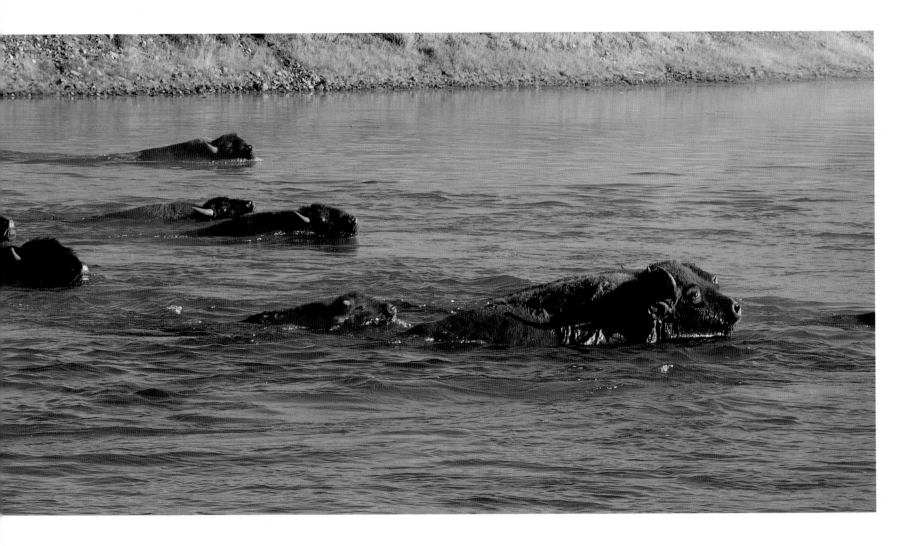

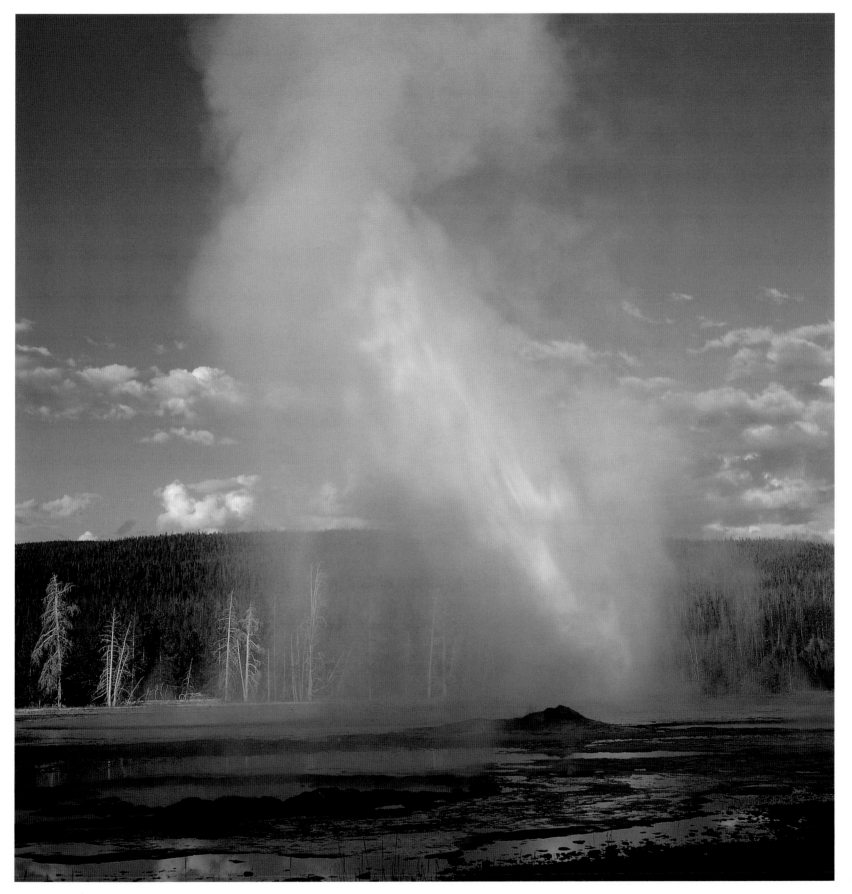

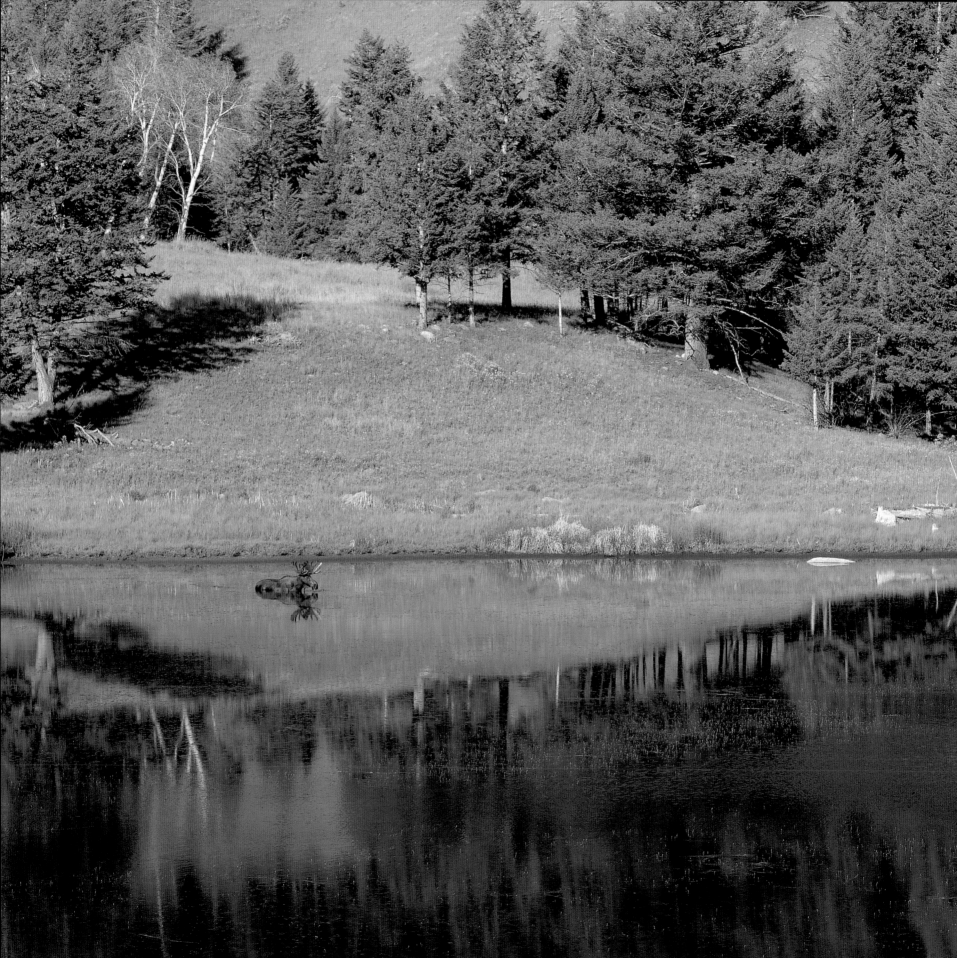

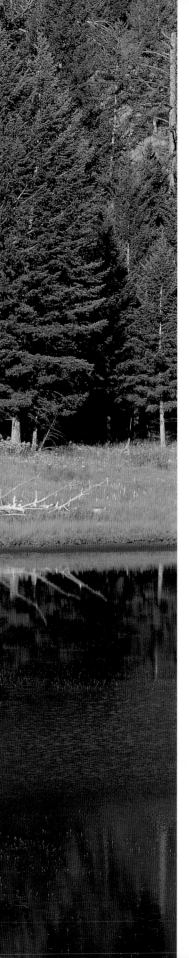

Left: A lone moose wades through the green waters of Floating Island Lake.

Below: Pronghorn antelope graze on the lush vegetation near the Specimen Ridge Trailhead, an area known for its petrified tree specimens.

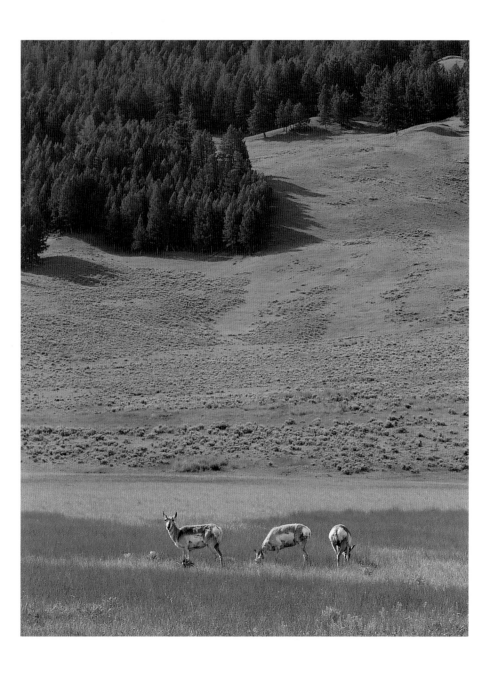

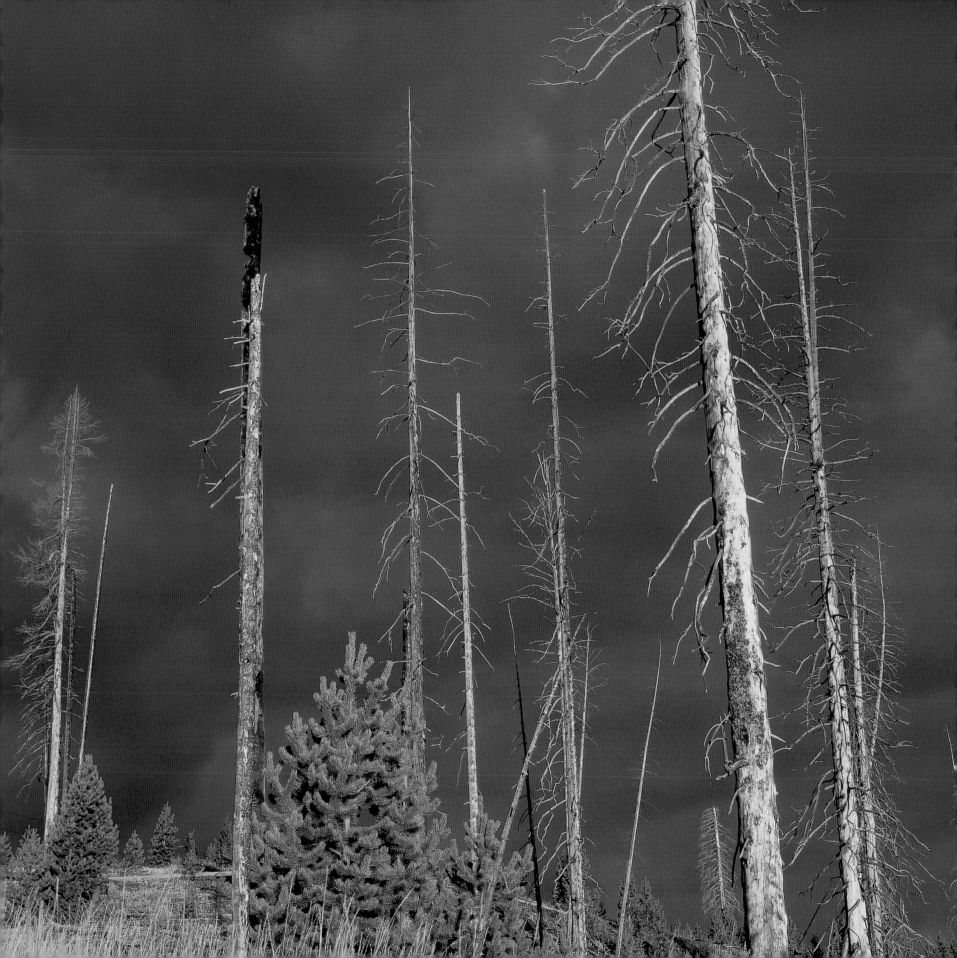

Left: Scarlet-colored paintbrush, one of the many wildflowers that bloom in Yellowstone National Park's open meadows and sagebrush steppes.

Facing page: Lodgepole pine snags are gold against a stormy sky.

Below: Lodgepole pines, naturally reseeded by fire, in Madison Canyon. The tree on the right is red because of disease or insect infestation, either the mountain pine beetle or the western budworm.

Right: A sunset stains the horizon magenta over West Thumb Geyser Basin.

Below: A bright moon shines over Midway Geyser Basin.

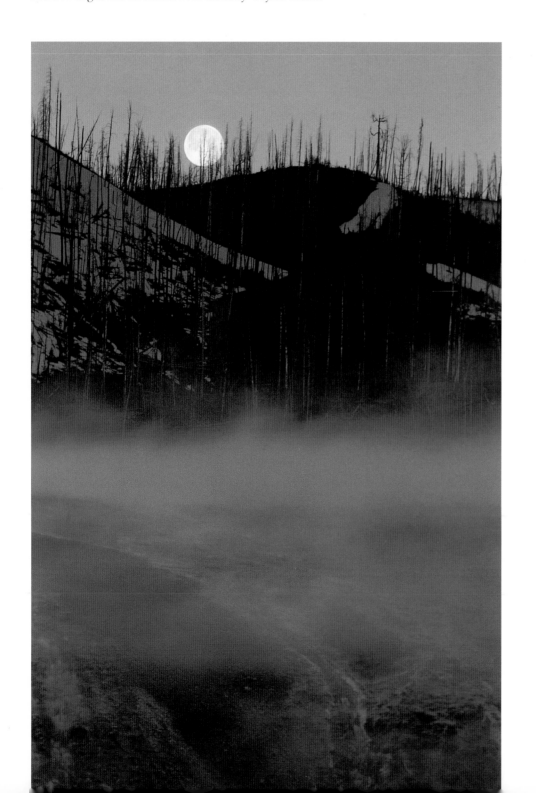

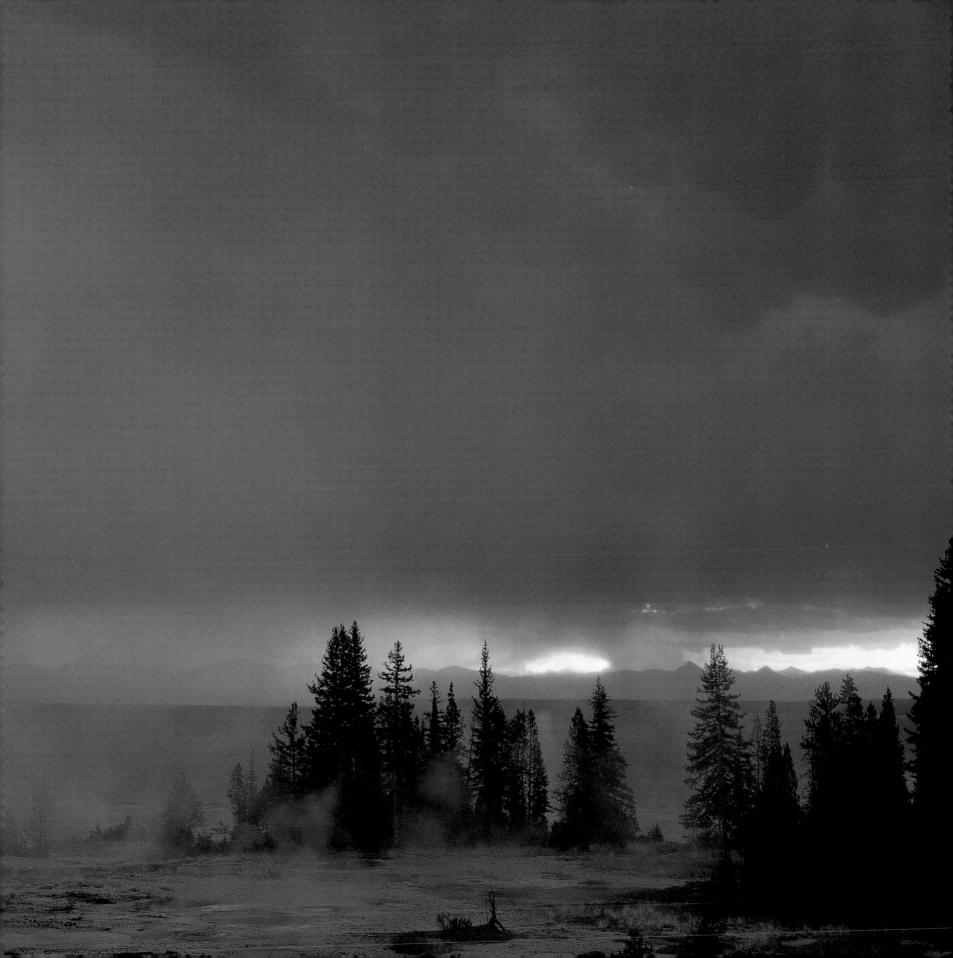

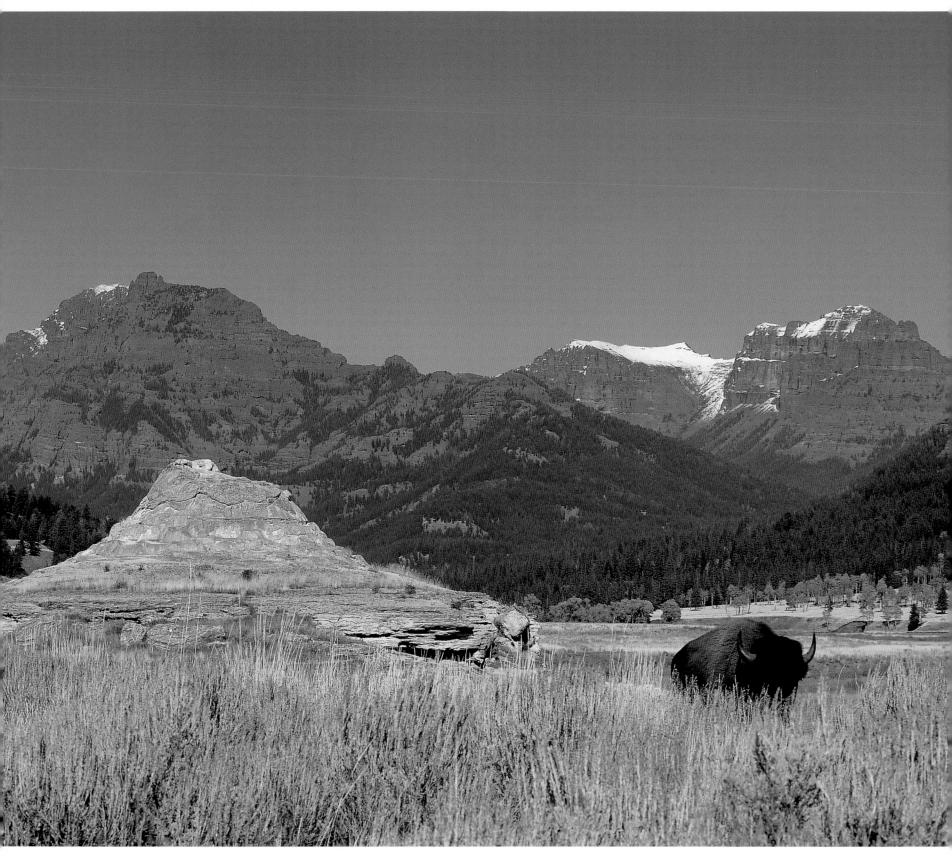

Left: A bison shoulders up over a rise in the Soda Butte area of northeast Yellowstone National Park.

Below: Black bear cubs climb high on a snag to escape a nearby grizzly.

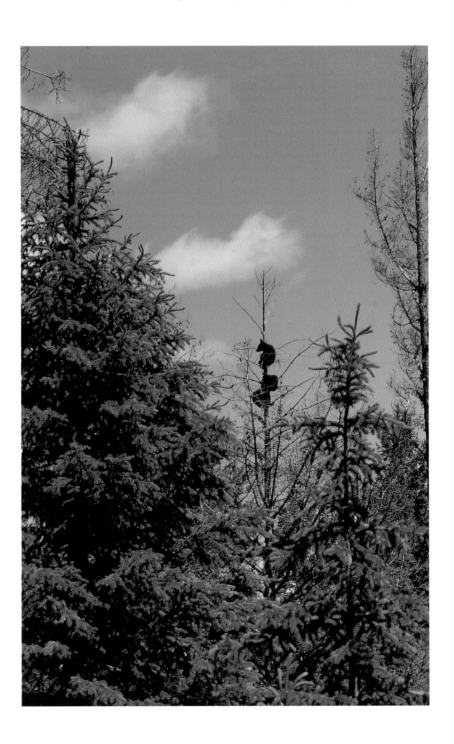

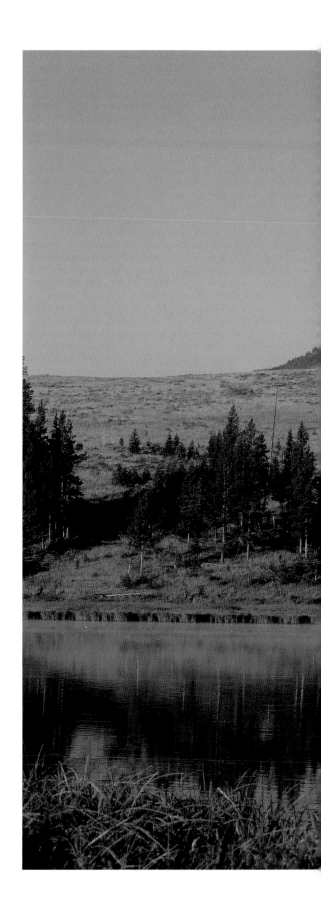

Right: Two large swans glide on the still waters of aptly named Swan Lake.

Below: Two golden-mantled ground squirrels perch on a rock on the grassy slopes of Mount Washburn.

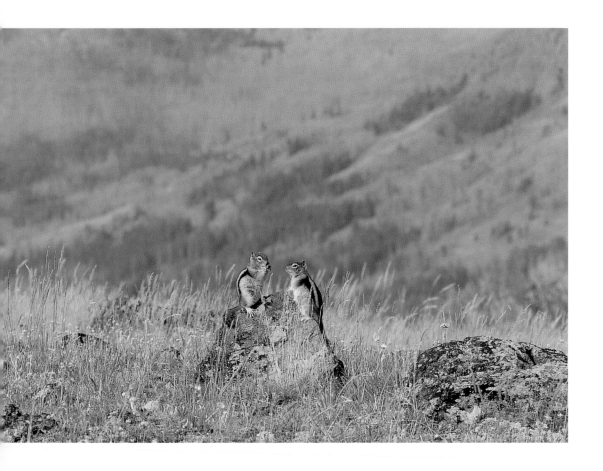

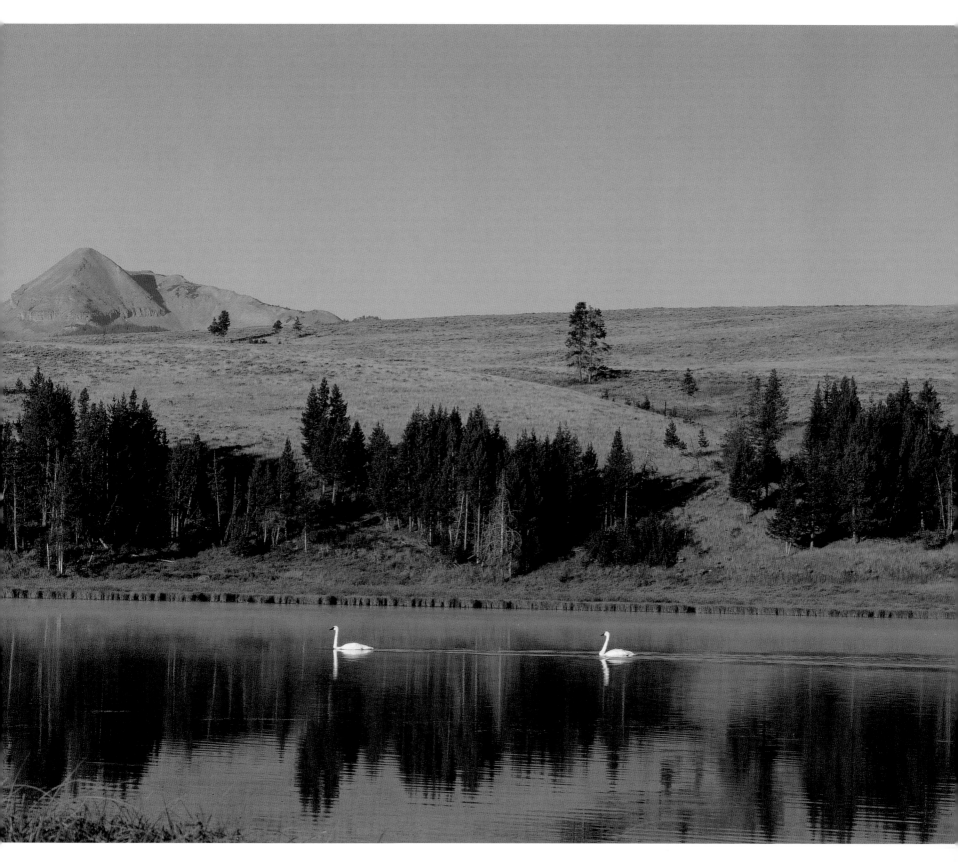

Right: Well adapted to climbing steep terrain, bighorn sheep gather on the rocky outcroppings in the northern part of the park.

Facing page: An elk cow and calf graze along the shore of Yellowstone Lake.

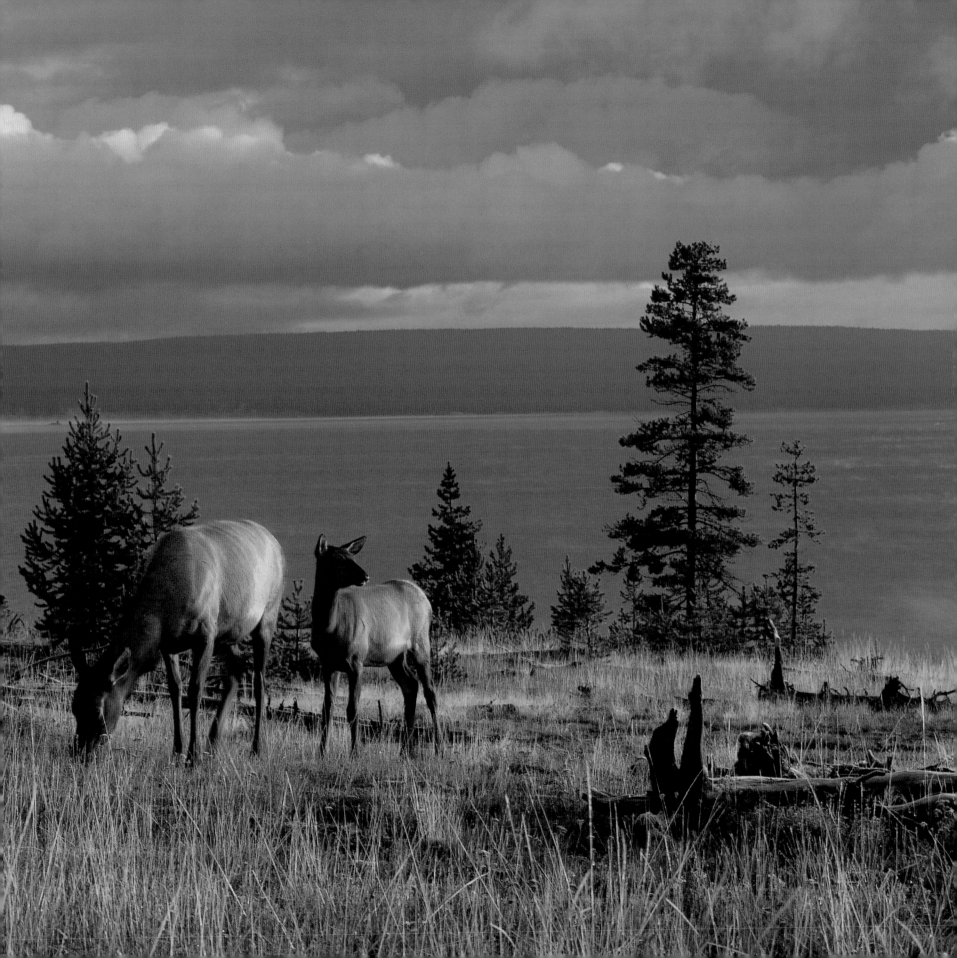

Right: From Lookout Point, visitors can enjoy this view of the 308-foot Lower Falls of the Yellowstone River.

Below: A black bear sow takes a nap on a large boulder.

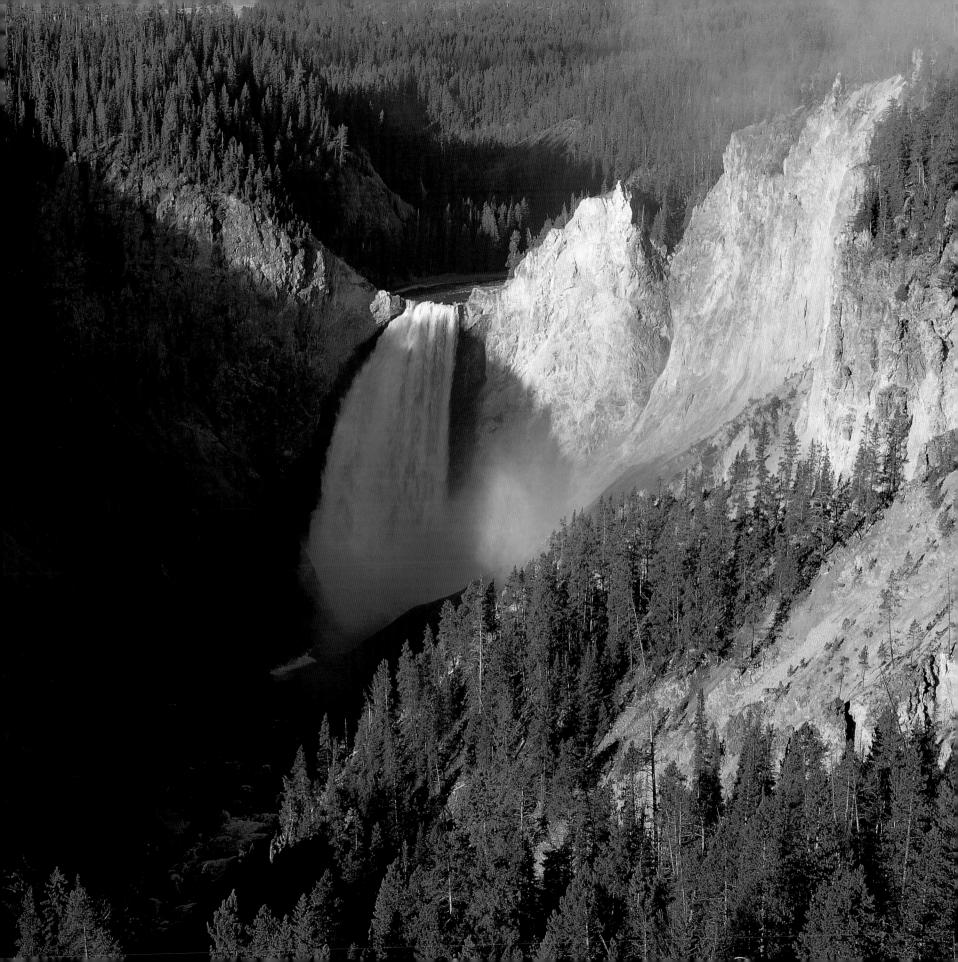

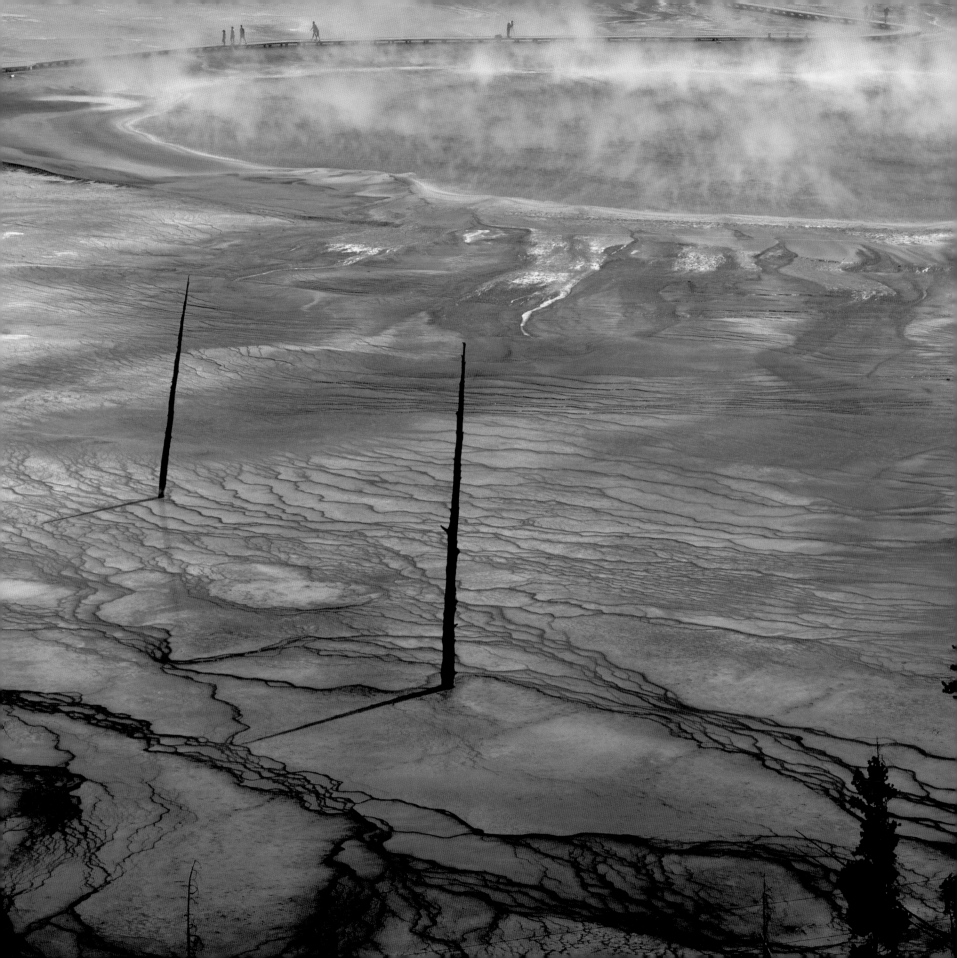

Left: Yellowstone National Park's largest hot spring, Grand Prismatic Spring, is 370 feet in diameter and more than 121 feet in depth.

Below: A close-up of one of the many mud pots in Pocket Basin.

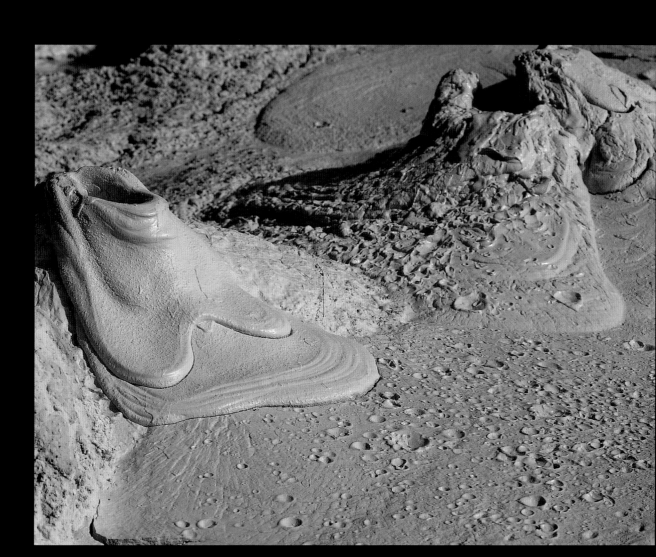

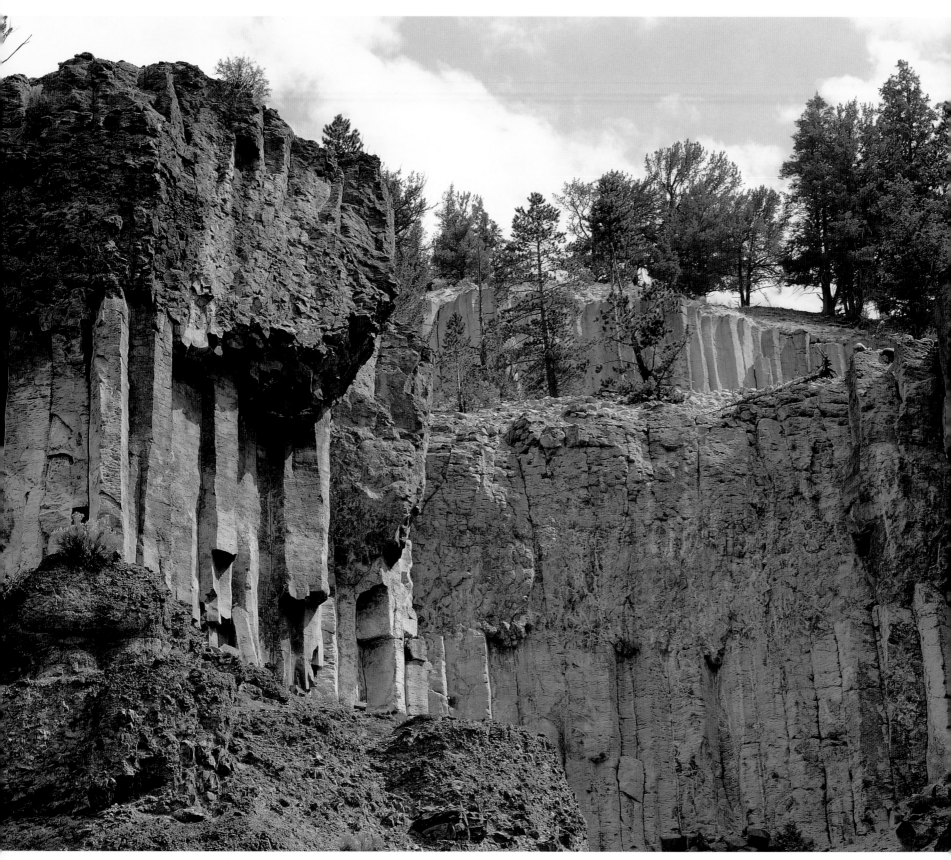

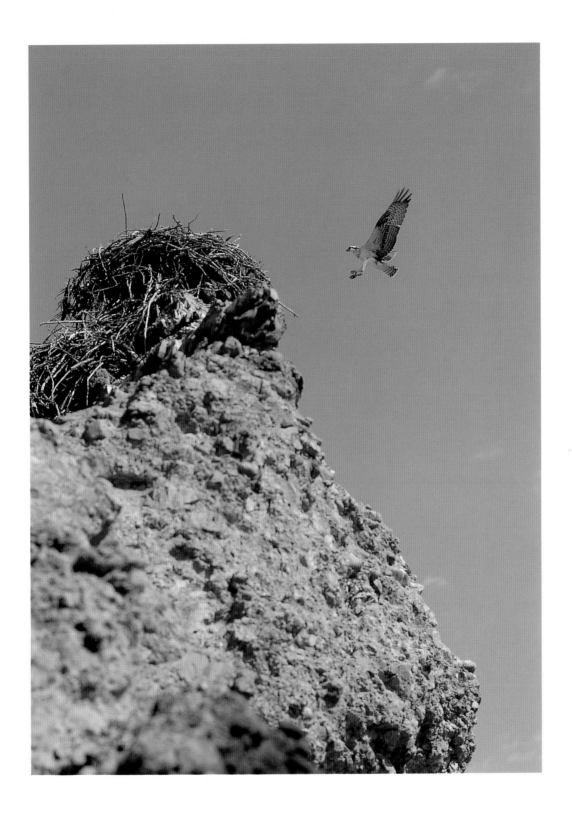

Left: Talons extended, an osprey prepares to land in its nest high atop a rocky outcropping.

Facing page: The basalt columns in the Tower Falls area were formed when basaltic lava cracked into the hexagonal columns, or "fence posts," as it slowly cooled.

Facing page: A lazy bend of the Yellowstone River as it winds through Hayden Valley, known as the "Serengeti of Yellowstone" for its abundant wildlife.

Below: A mountain goat on Yellowstone National Park's Barronette Peak.

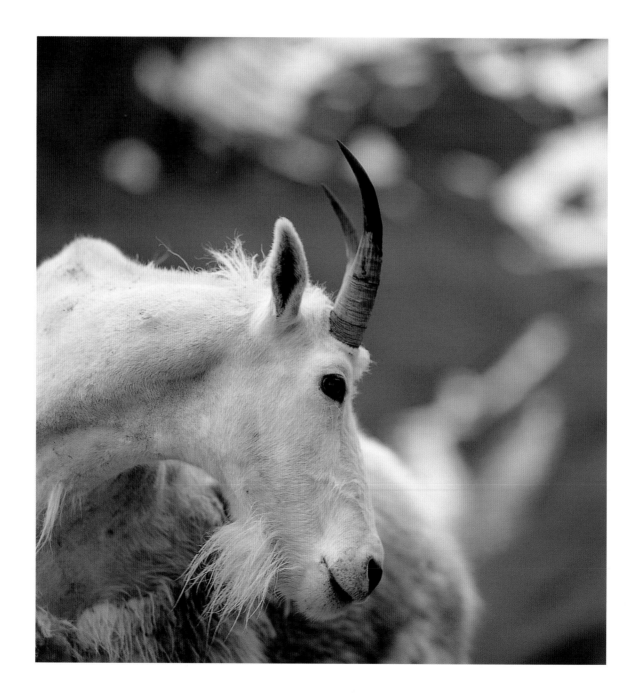

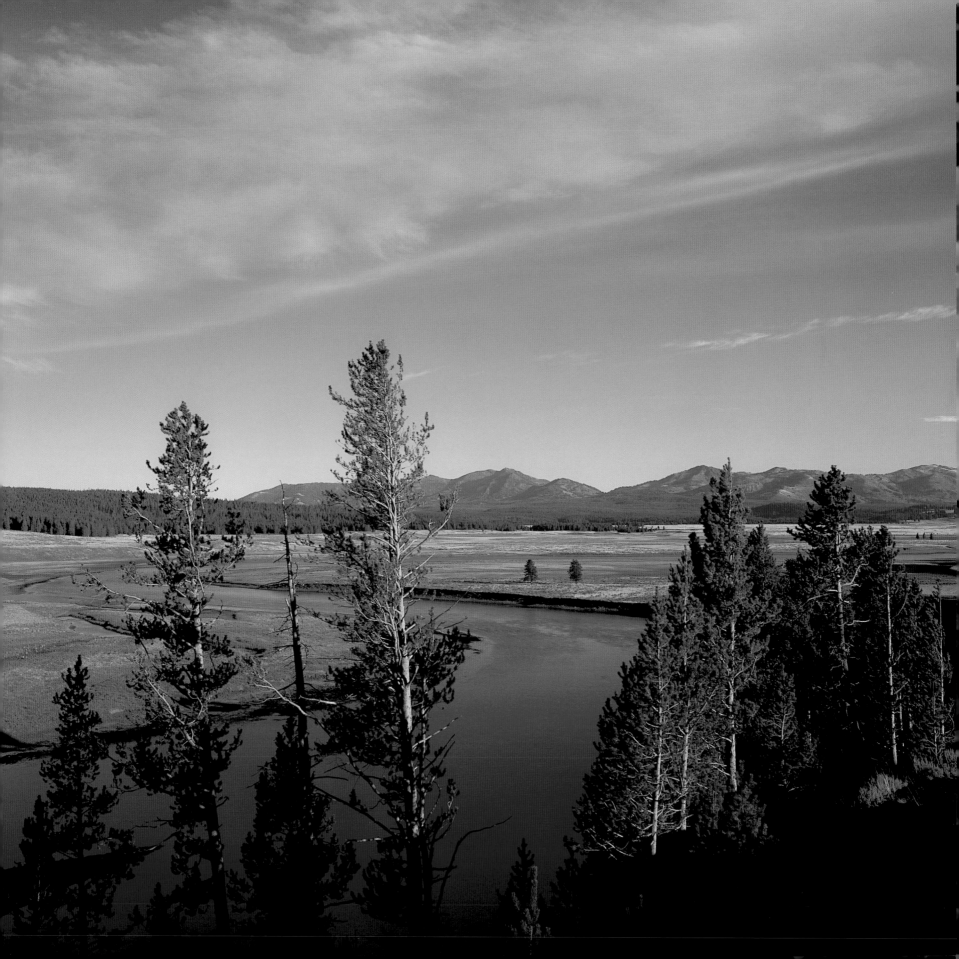

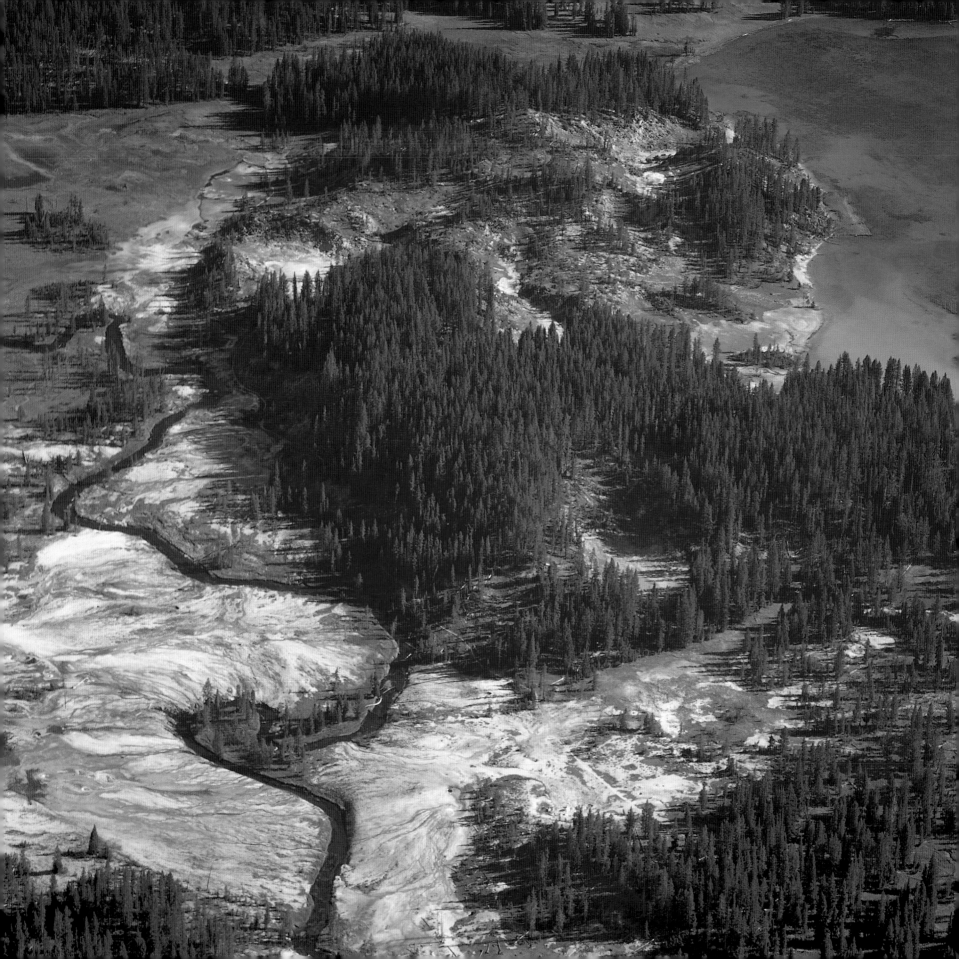

Left: Shoshone Geyser Basin lies on the westernmost tip of Shoshone Lake, the largest backcountry lake in the United States.

Below: An unnamed spring near Narrow Gauge Terrace at Mammoth Hot Springs.

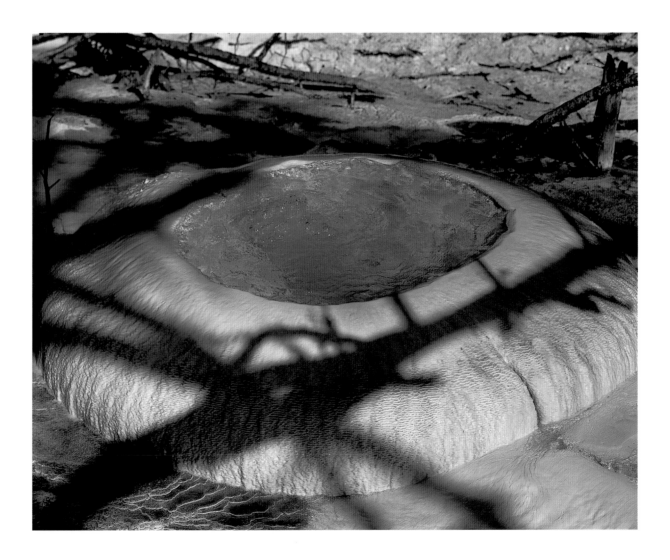

Right: The mist from 197-foot Fairy Falls moistens the vegetation that surrounds it, including this young lodgepole pine.

Facing page: A young bison walks among the "bobby sock trees" in Black Sand Basin, so-named because of the small granules of obsidian scattered throughout the area.

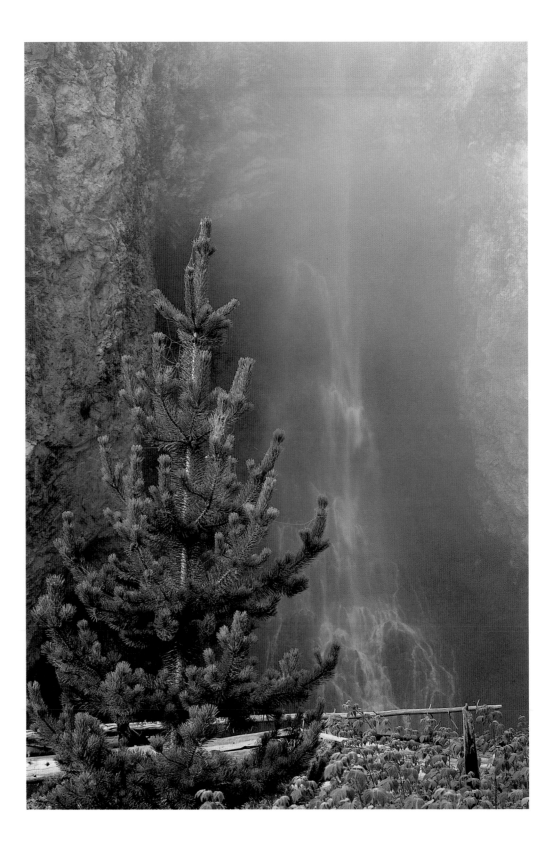

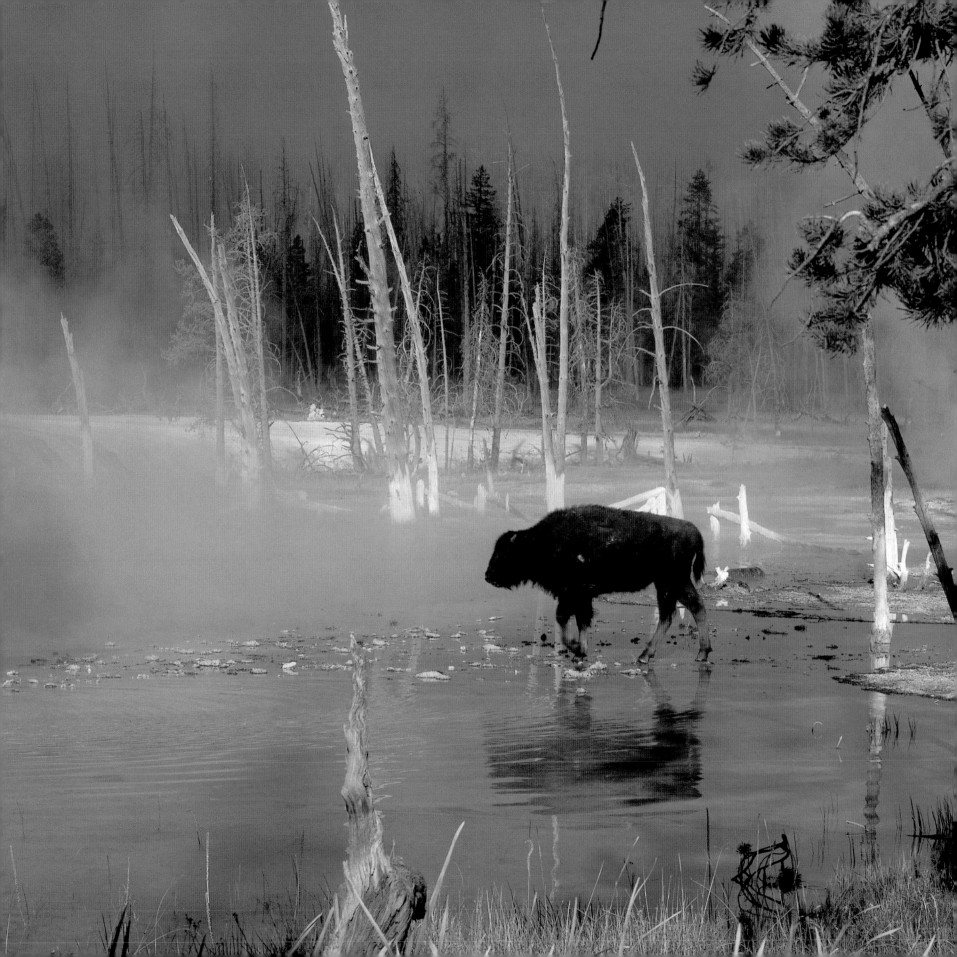

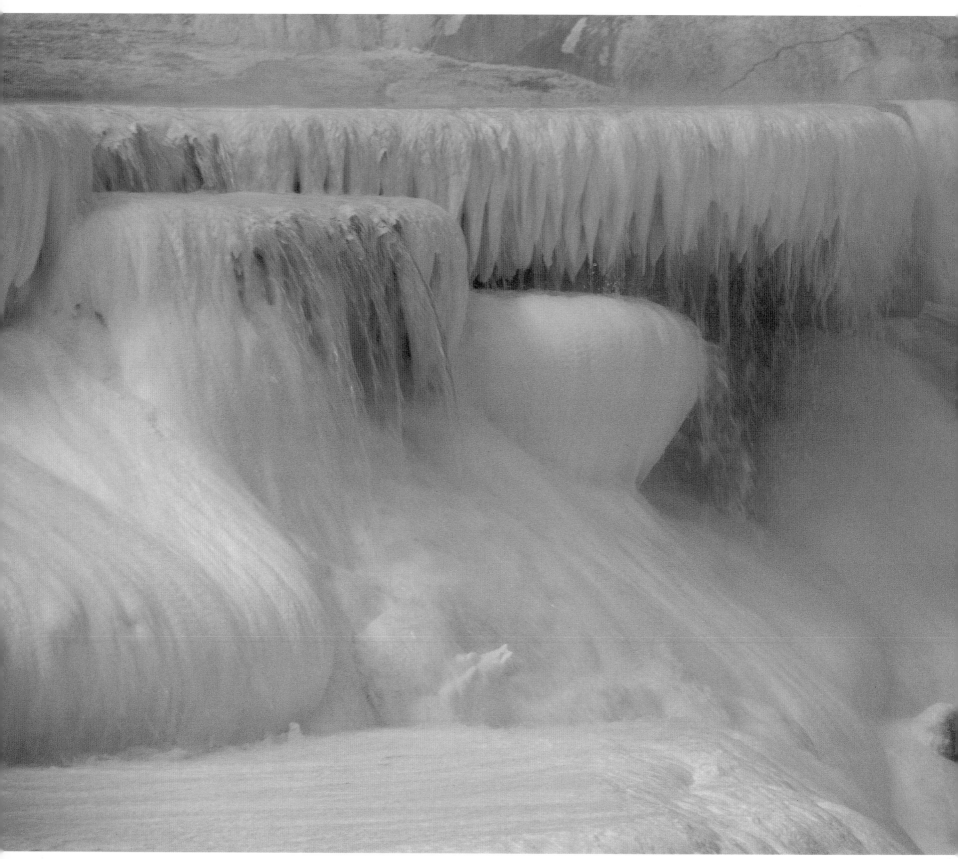

Left: Minerva Terrace at Mammoth Hot Springs is composed of travertine, a form of calcium carbonate. This image shows Minerva when it was still active. PHOTO BY TONY HUHN

Below: The popcorn-like formations at Fortress Geyser.

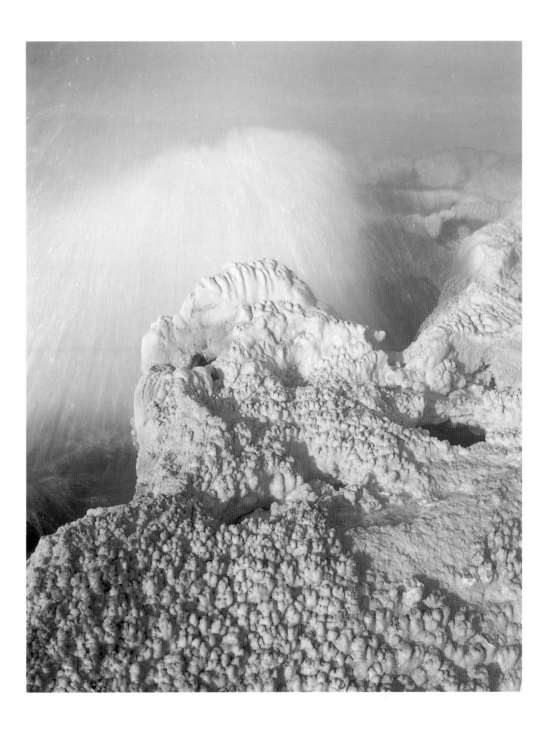

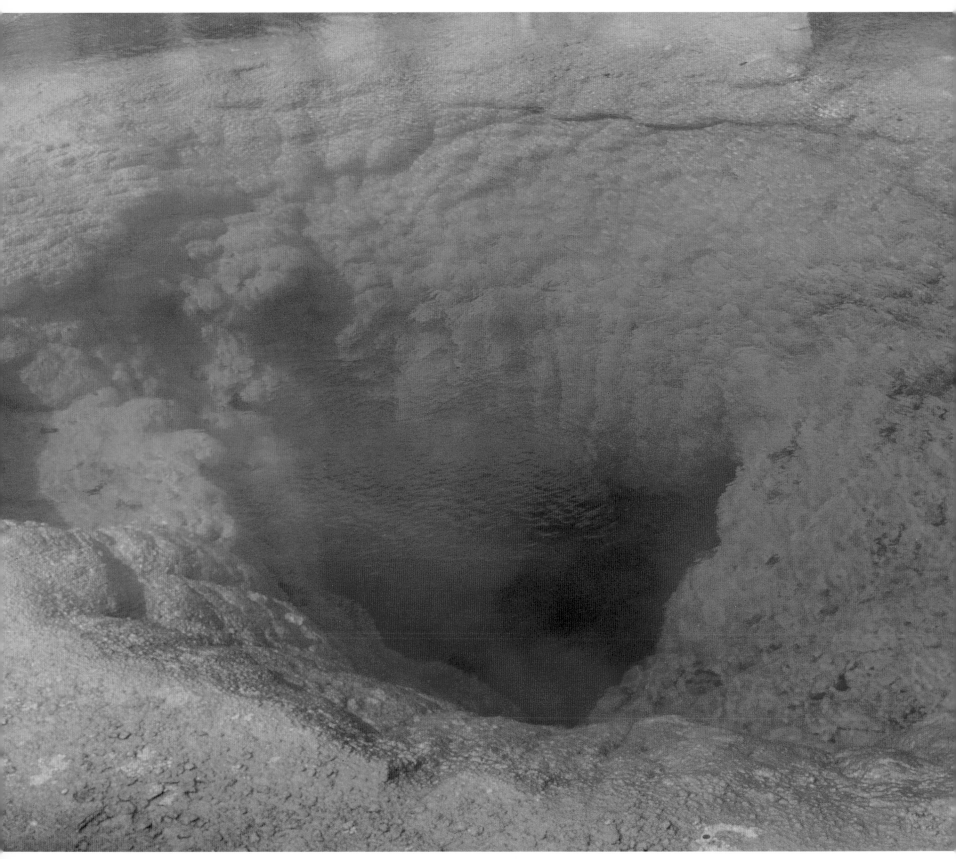

Left: A perennial favorite among visitors, the multi-hued Morning Glory Pool was named in the 1880s for its similarity to the flower of the same name. PHOTO BY TONY HUHN

Below: Imperial Geyser is part of a spectacular backcountry hydrothermal area.

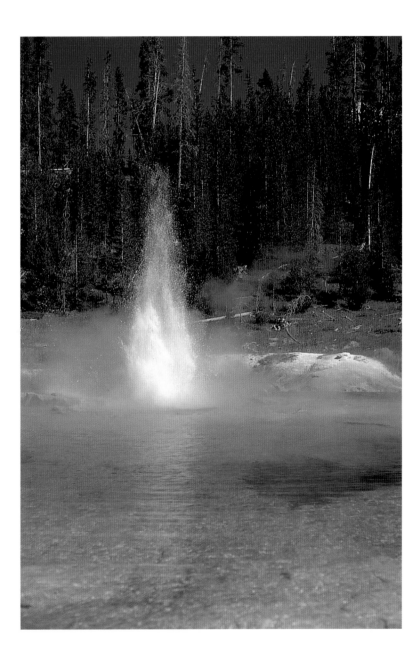

Snow blankets 10,404-foot Barronette Peak
near the park's northeast entrance.

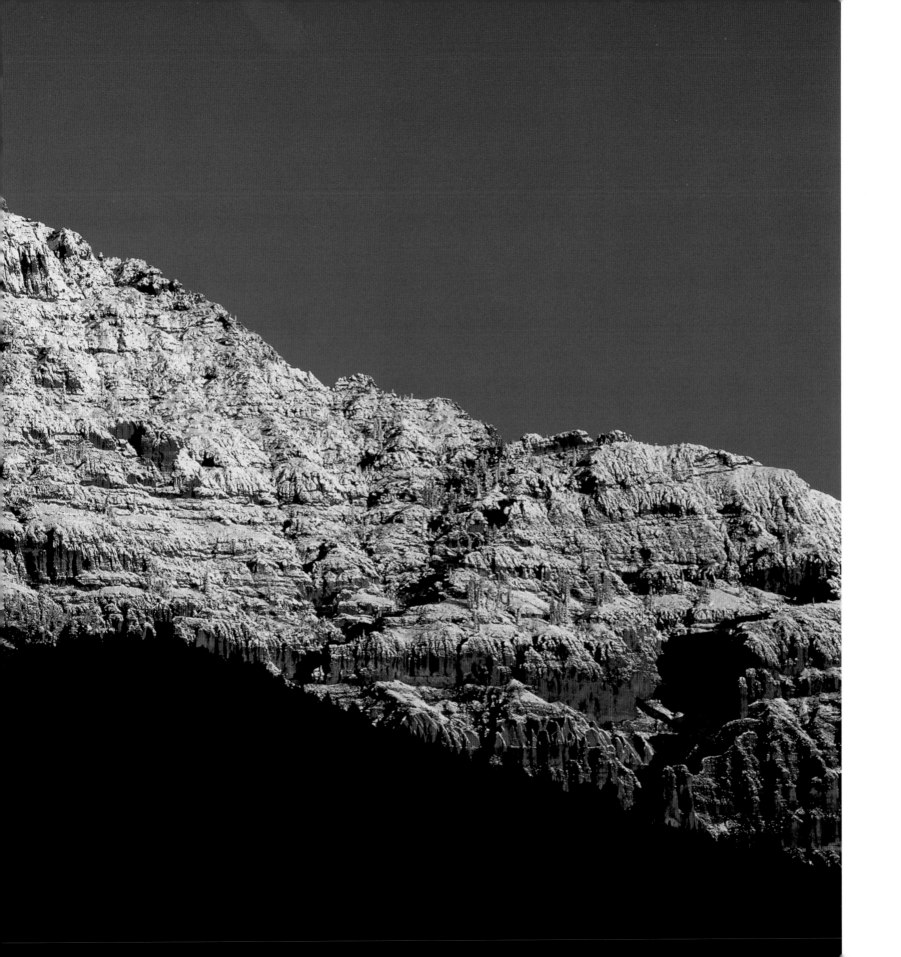

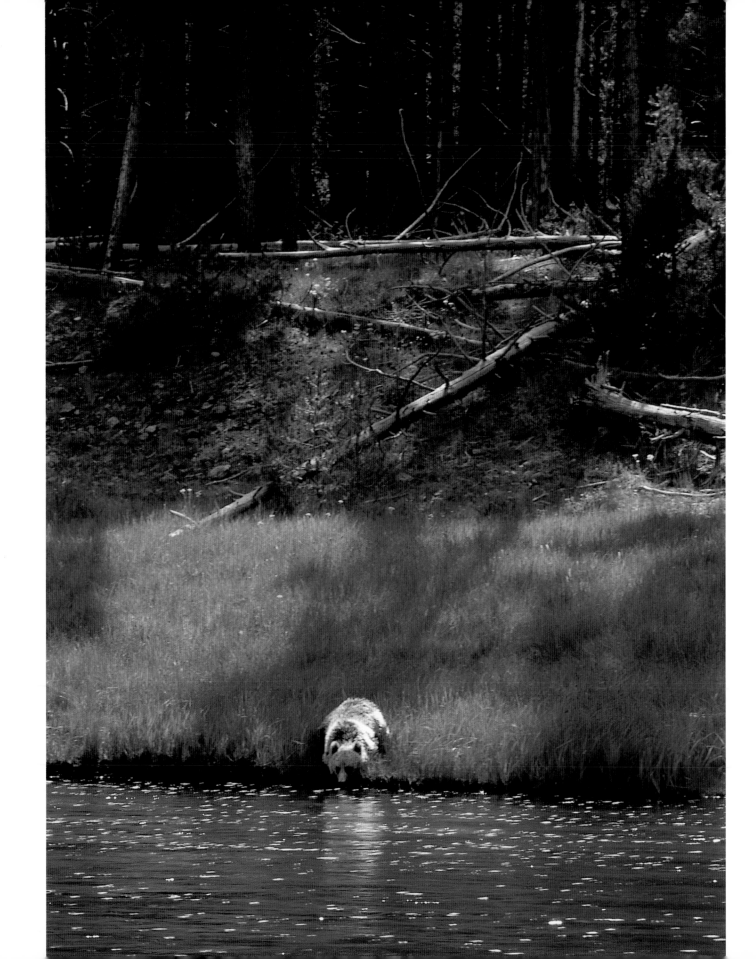

A grizzly bear takes a drink from the Firehole River.

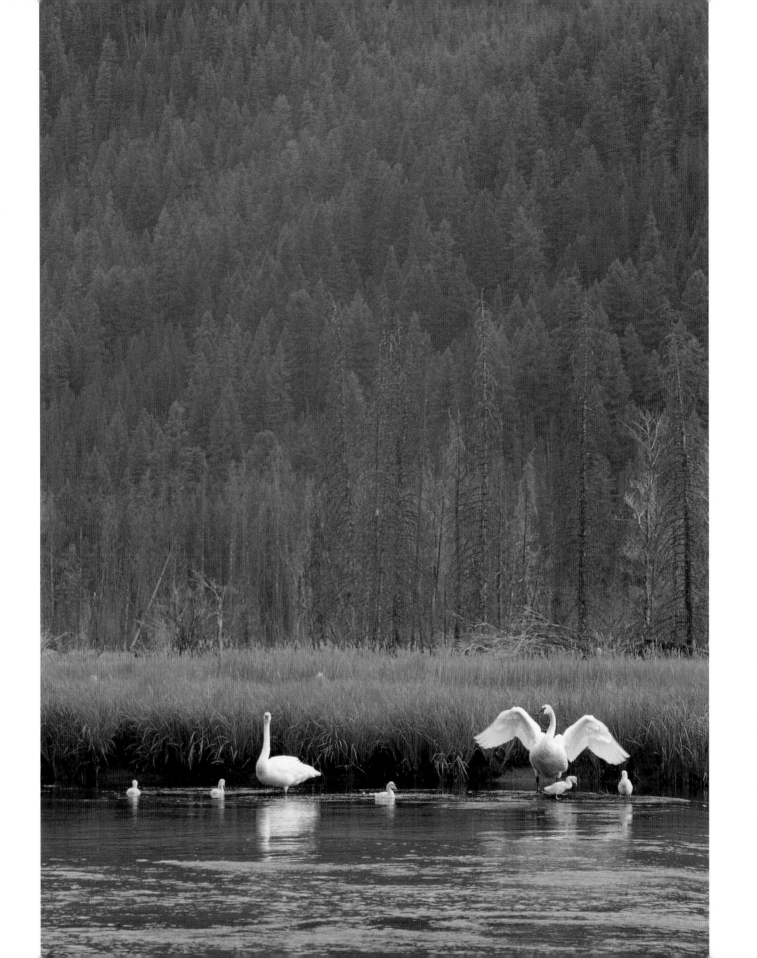

Regarded as the largest of all North American wildfowl, trumpeter swans and their cygnets take a quiet swim on the Madison River.

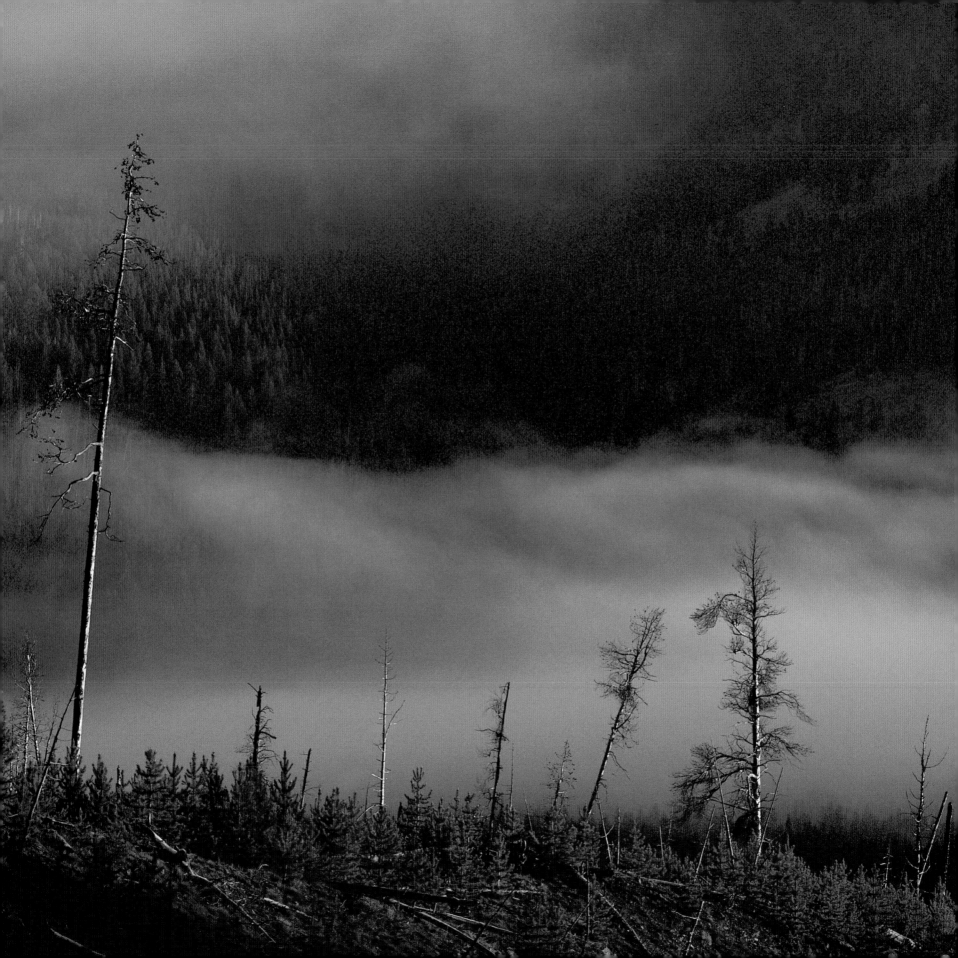

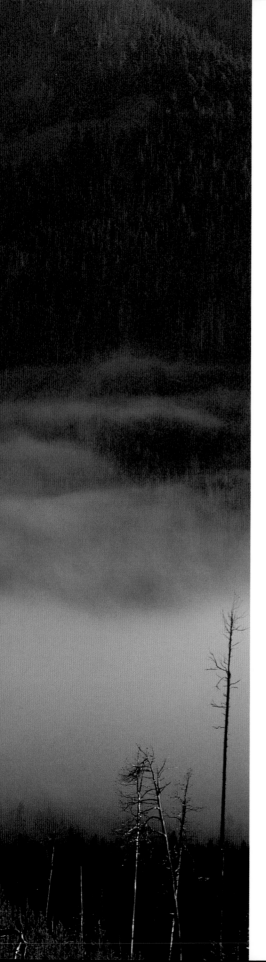

Left: Purple Mountain features a six-mile hiking trail that rises through intermittent lodgepole forests to views of the Firehole Valley and lower Gibbon Valley.

Below: Lupine bloomed profusely after the 1988 fire in Yellowstone National Park.

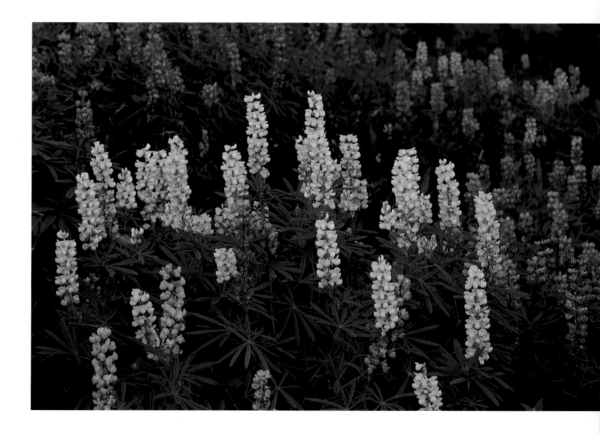

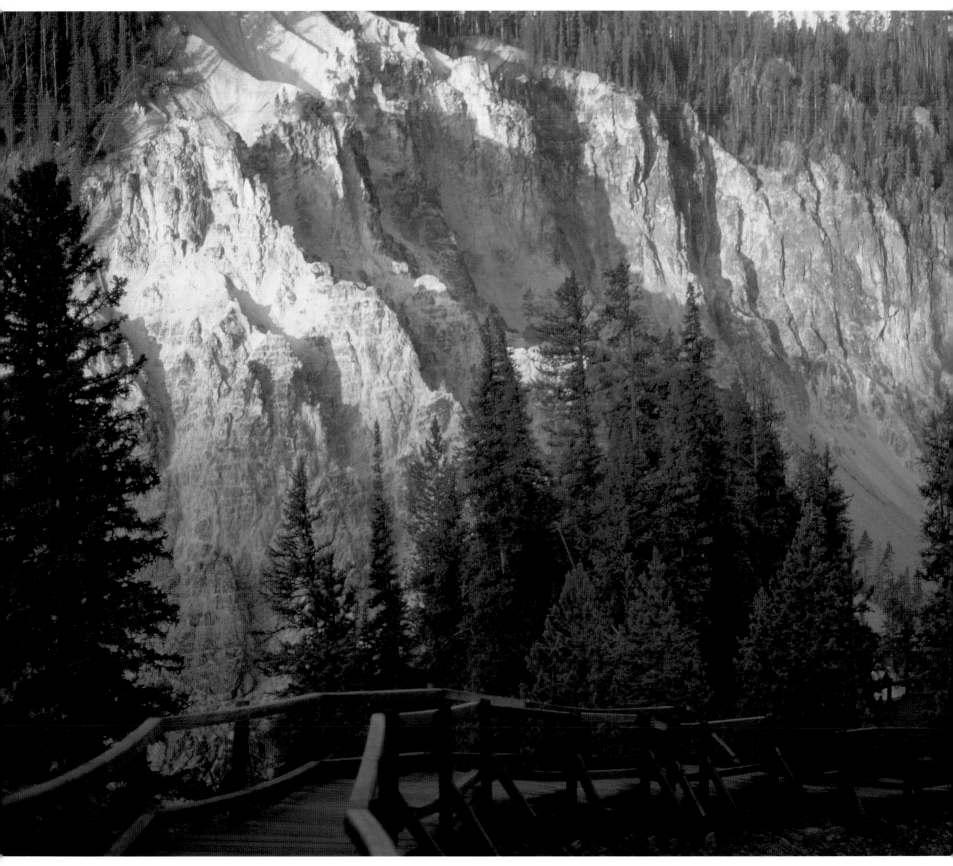

Left: Visitors enjoy views from the trail leading to Red Rock Point at the Grand Canyon of the Yellowstone.

Below: The vivid waters of 25-foot-deep Emerald Pool at Black Sand Basin.

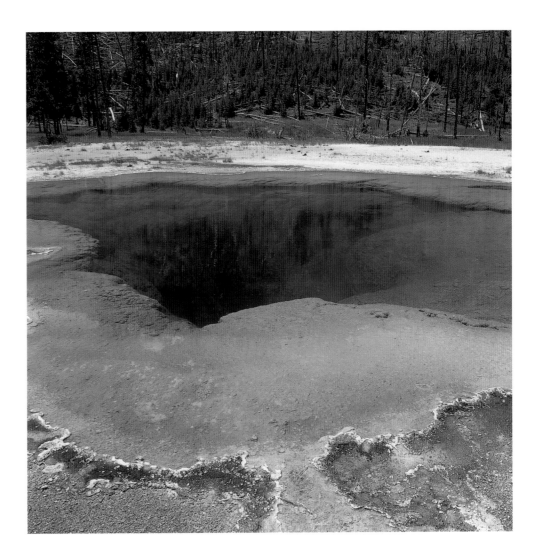

Right: Mist from distant Imperial Geyser, which is within the boundary of the ancient Yellowstone caldera.

Below: Mud pots occur when underground water and gas combine to form an acid that dissolves surface rock into mud.

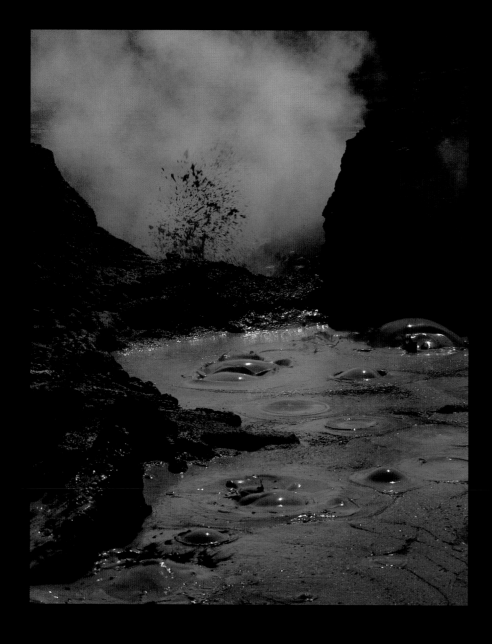

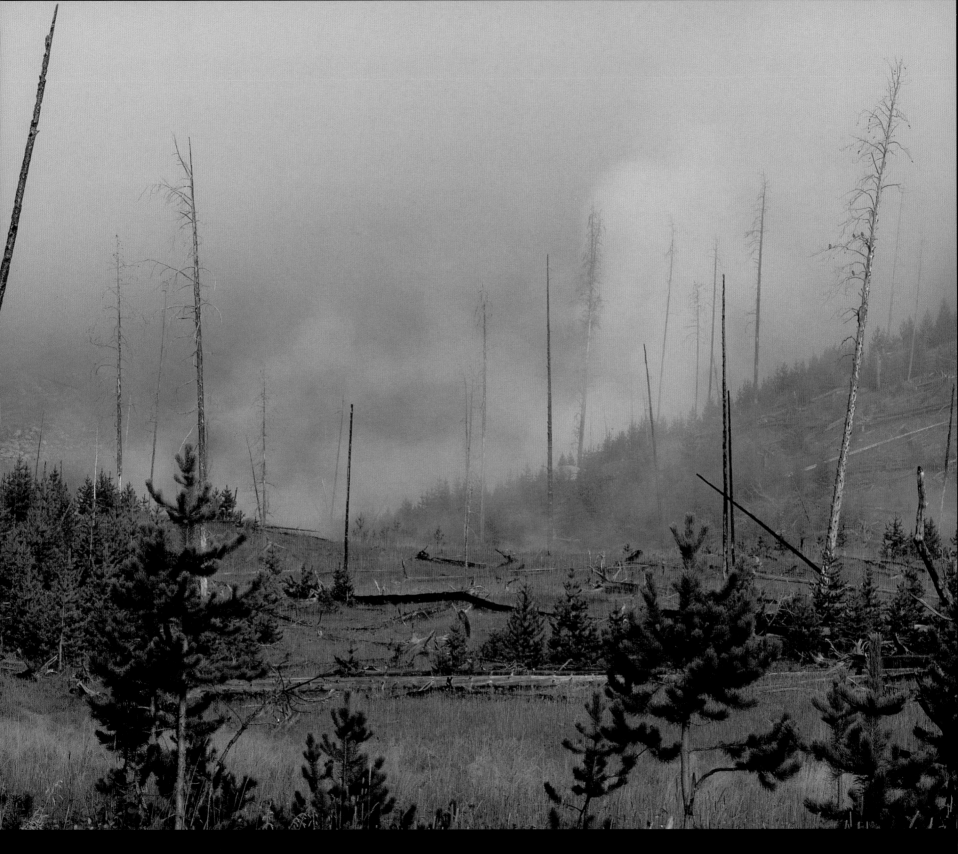

Facing page: A tower of water and steam rises from Giant Geyser, one of a number of spectacular thermal features that can be seen from the three-mile walk around Upper Geyser Basin.

Below: This hot spring is surrounded by the characteristic light-colored geyserite or sinter covered with colorful bacteria.

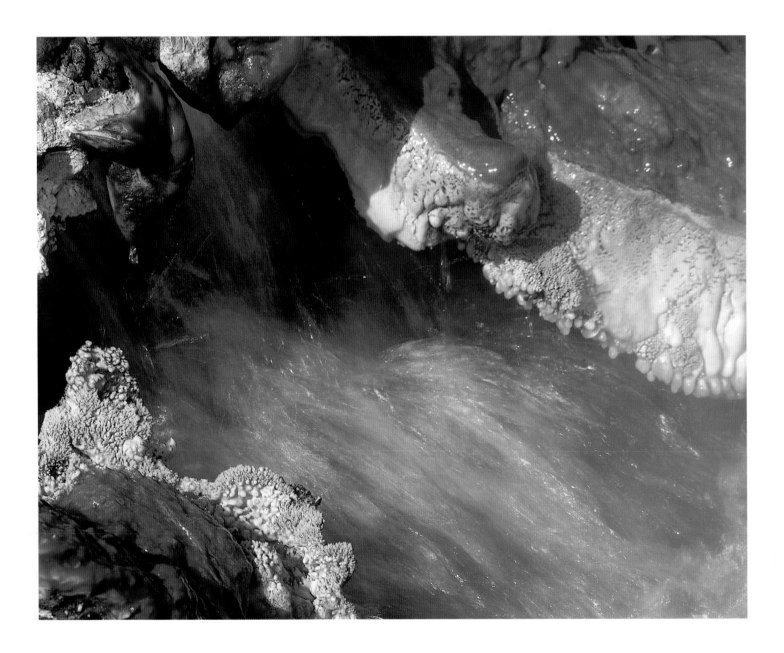

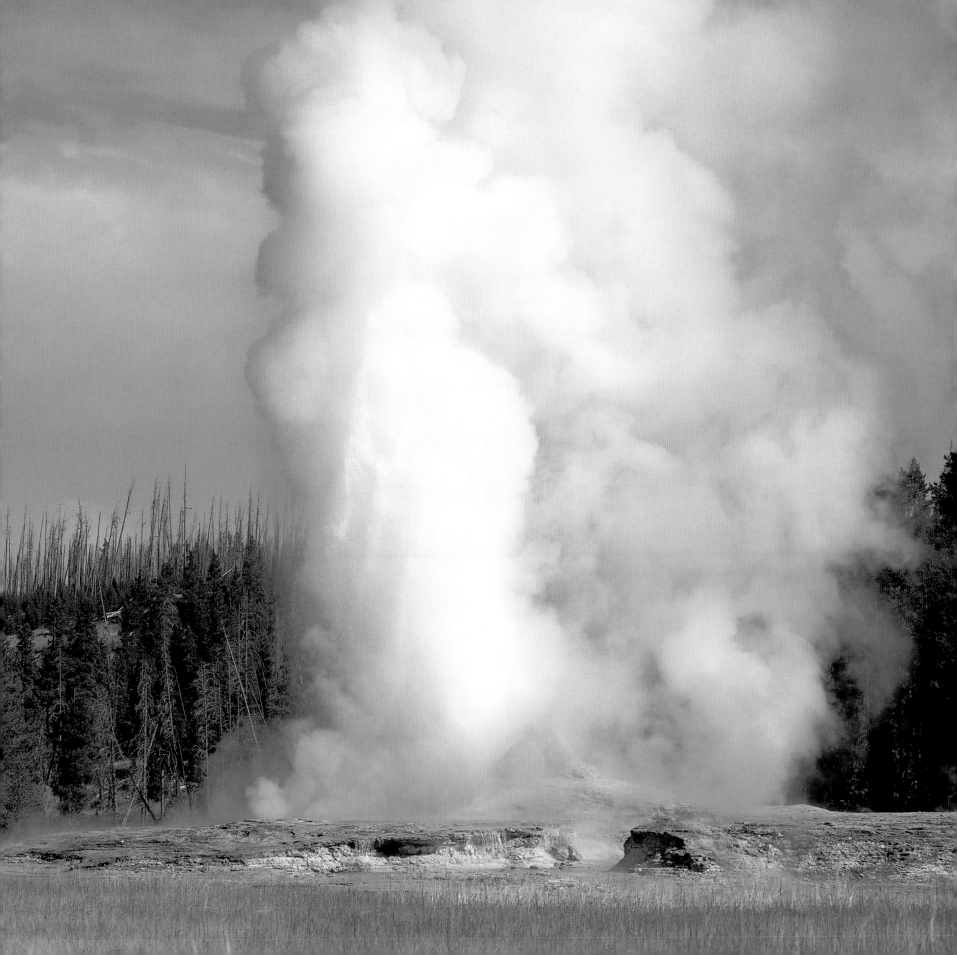

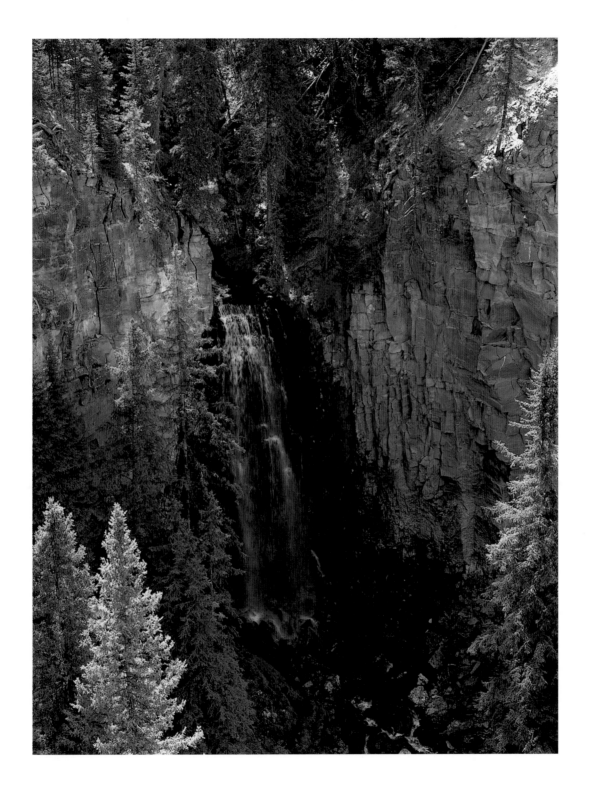

Left: Situated in the Tower-Roosevelt area of Yellowstone National Park, Lost Creek Falls makes an icy plunge to the river below.

Facing page: Mule deer bucks cross the Firehole River.

Facing page: Viewed from Artist Point, the spectacular ridges and crevices of the Grand Canyon of the Yellowstone are highlighted in early morning light.

Below: Brilliant streams of run-off from the aptly named Chocolate Pot.

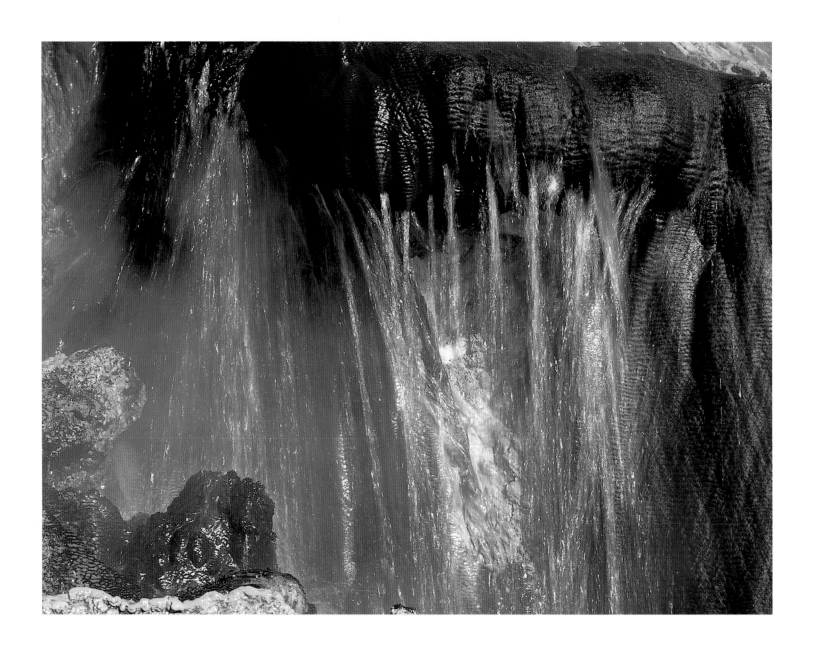

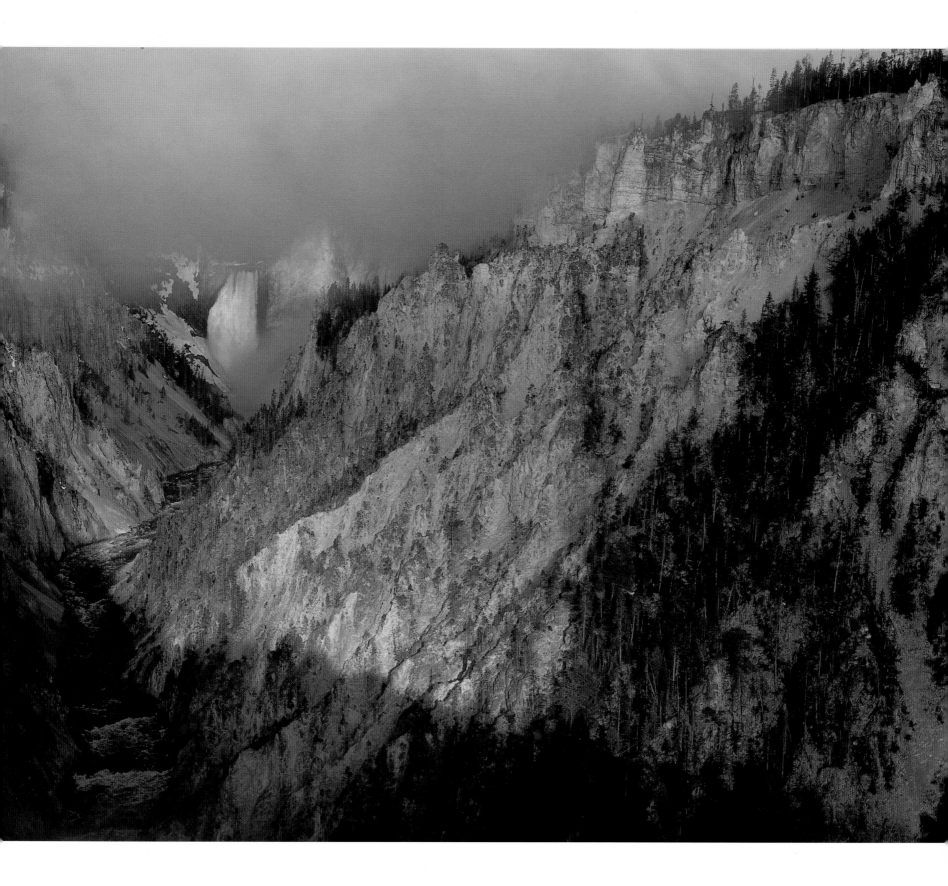

Right: The fringed gentian is the official flower of Yellowstone National Park.

Facing page: Osprey nest on a rocky outcropping at the Narrows, just downstream from Tower Falls.

Below: Bright-pink blooms of sticky geranium amid pine branches.

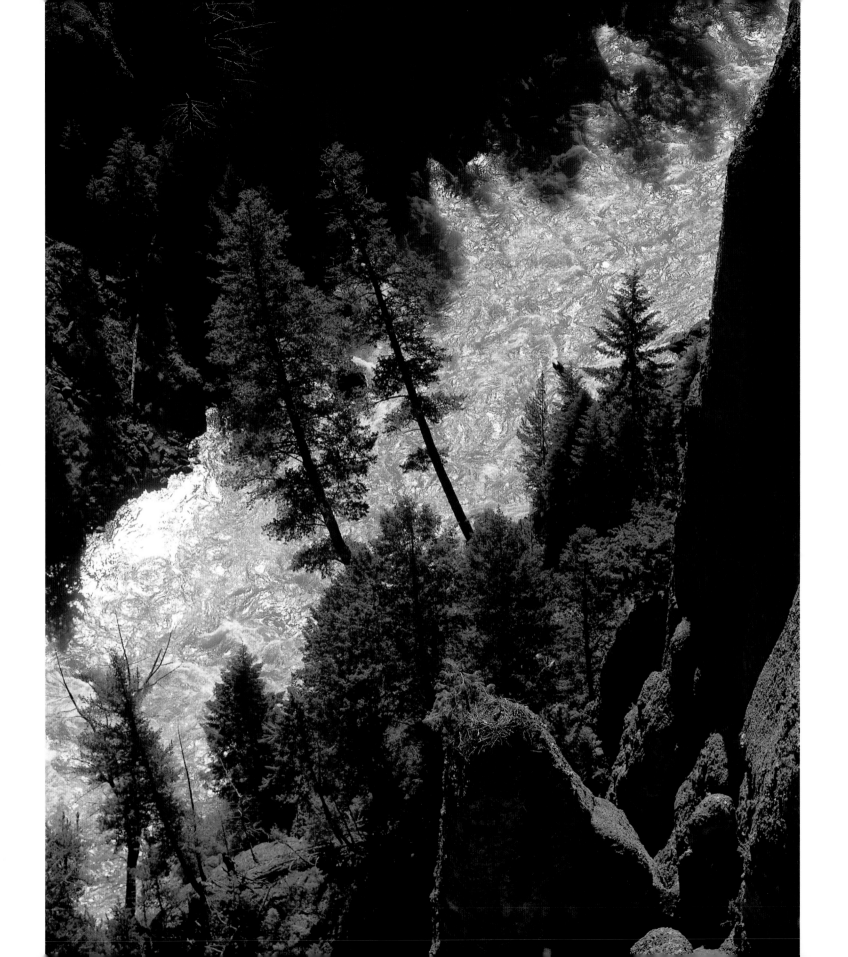

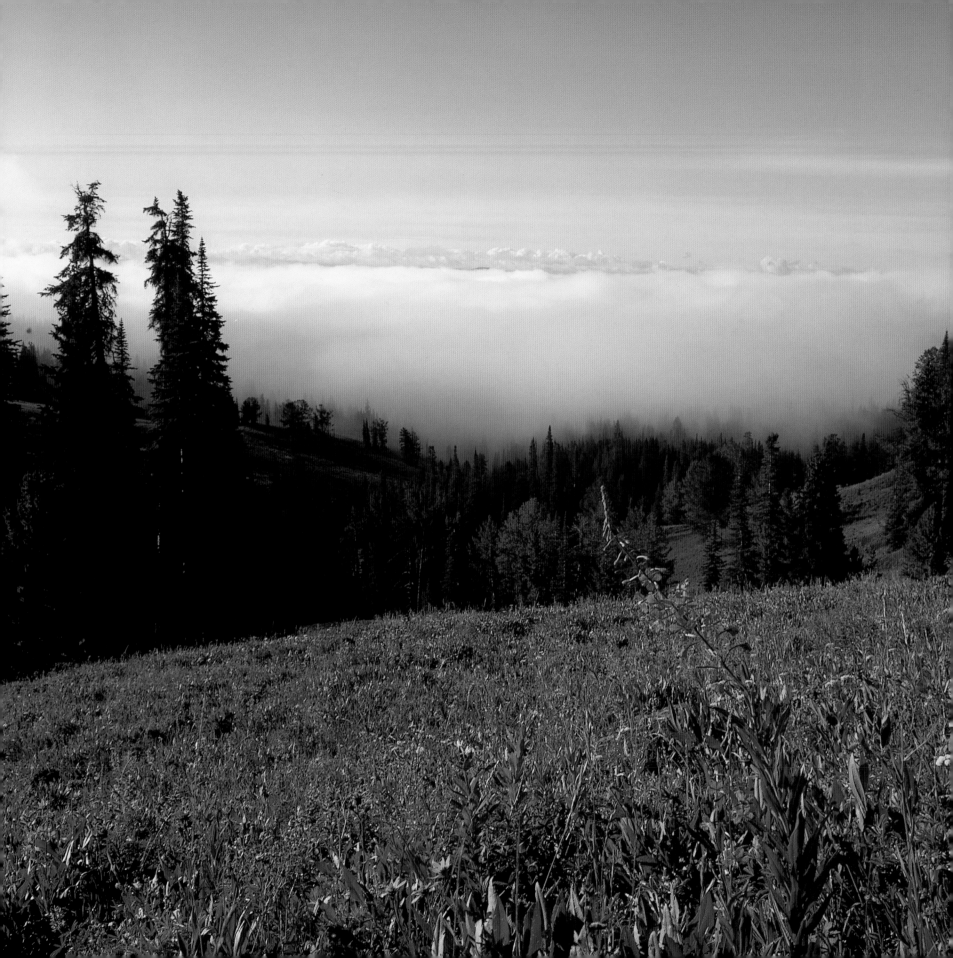

Facing page: Fuchsia-colored fireweed dots Dunraven Pass, where a trail leads to the 10,243-foot summit of Mount Washburn.

Below: A grizzly bear takes a drink at Mary Bay in Yellowstone Lake. Researchers have found that Mary Bay contains many hot springs, giving it the unofficial name "Alka Seltzer Springs."

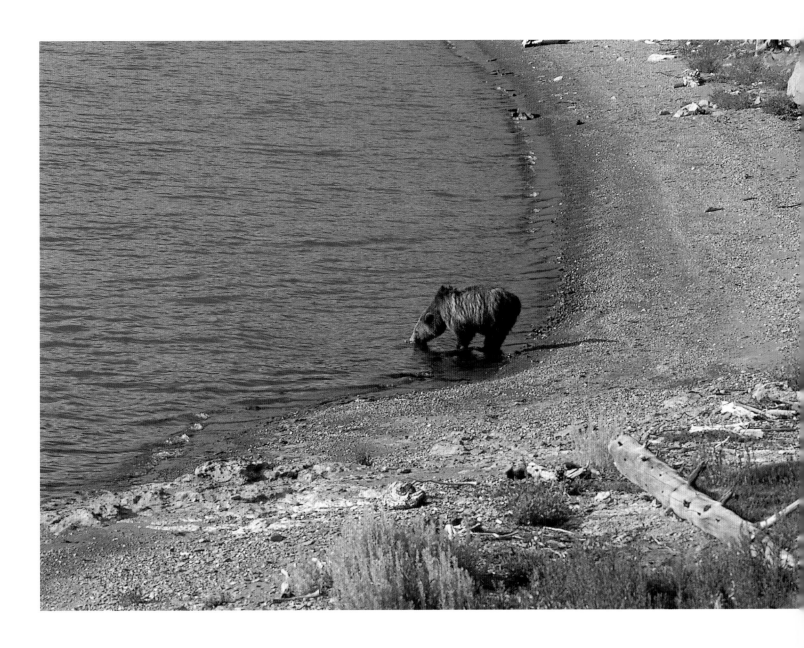

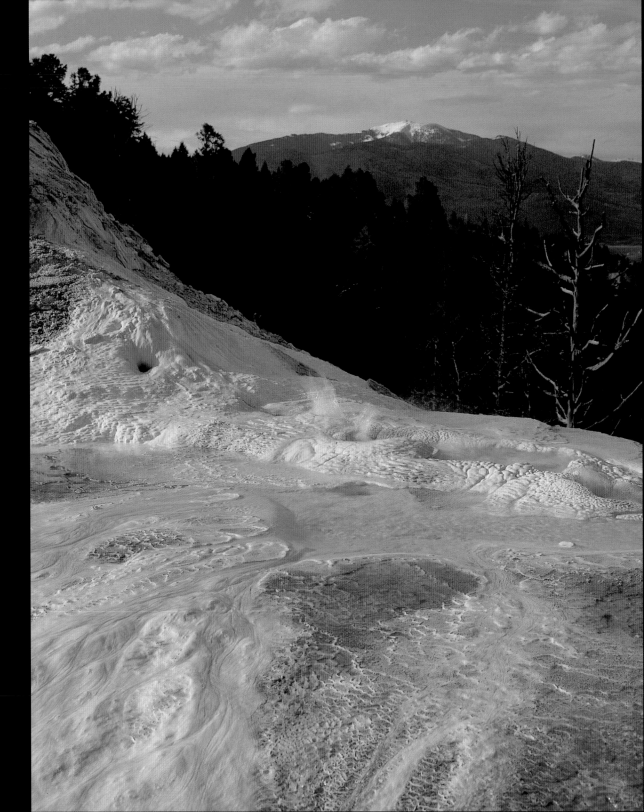

Right: Narrow Gauge Terrace at Mammoth Hot Springs is coated with white and rust-colored travertine. Travertine is white when fresh, and becomes tinged by algae and bacteria.

Facing page: Fortress Geyser in Lower Geyser Basin is one of a number of off-trail geysers in Yellowstone National Park. Geysers are the park's rarest thermal features.

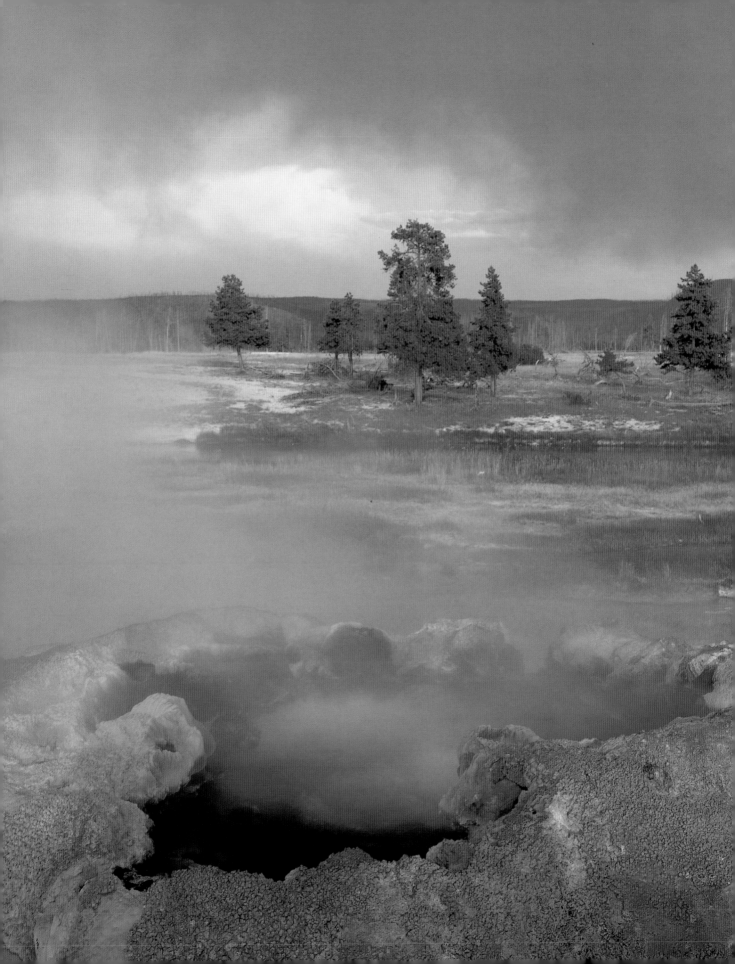

Right: The rocky terrain around Specimen Ridge—which has the largest concentration of petrified trees in the world—is typical of the northern part of the park.

Below: This view from the Sulfur Hills features the wildlife-rich Pelican Valley and the Absaroka Range, which boasts eight summits that exceed 12,000 feet in elevation.

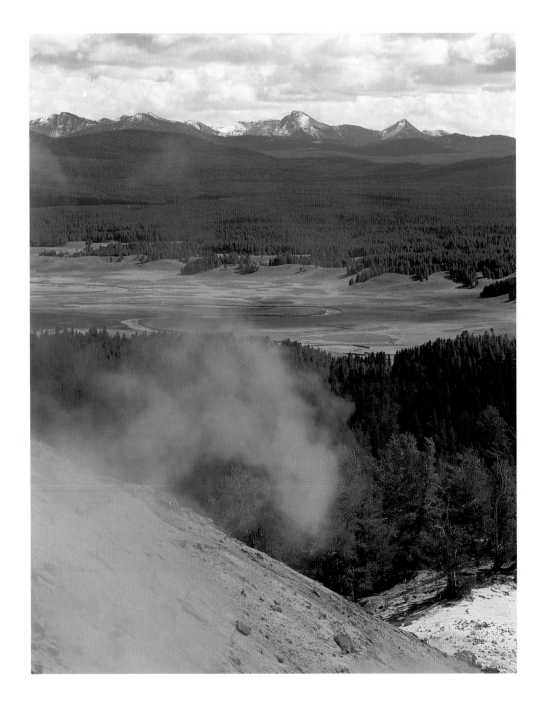

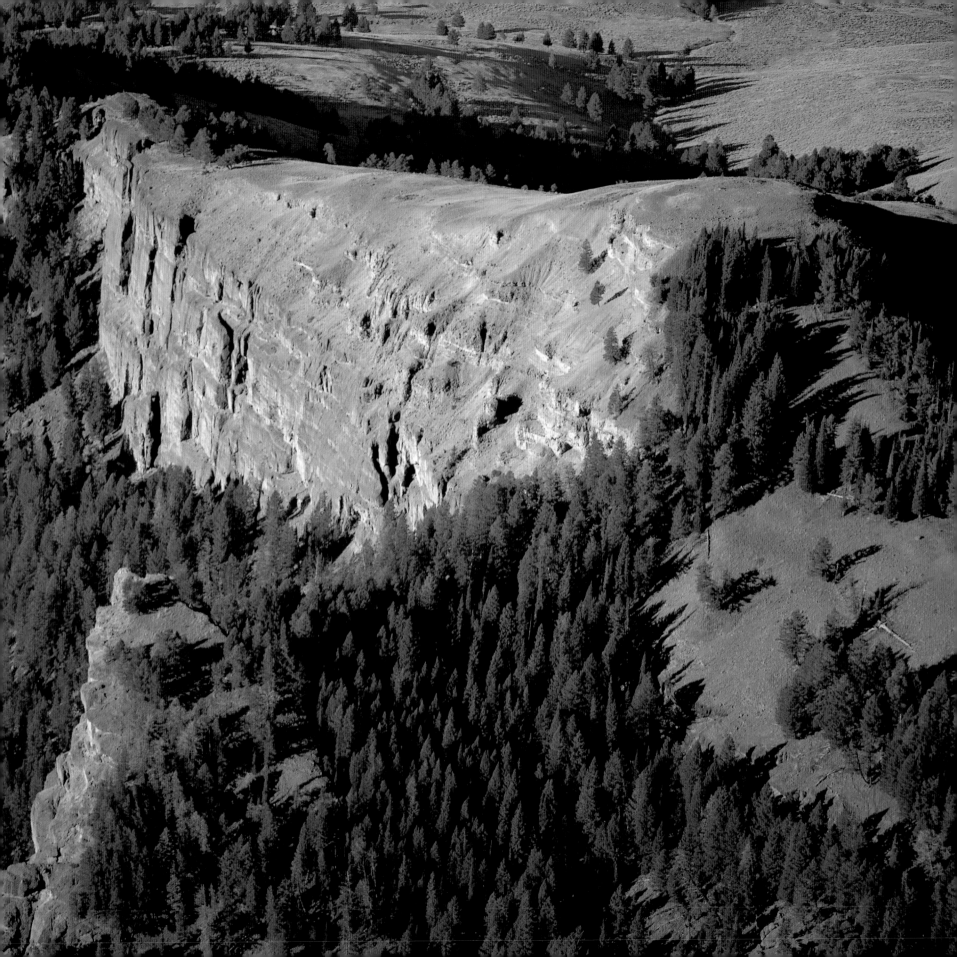

This silhouetted grizzly bear
seems to be taking in the
sunrise at Yellowstone Lake.

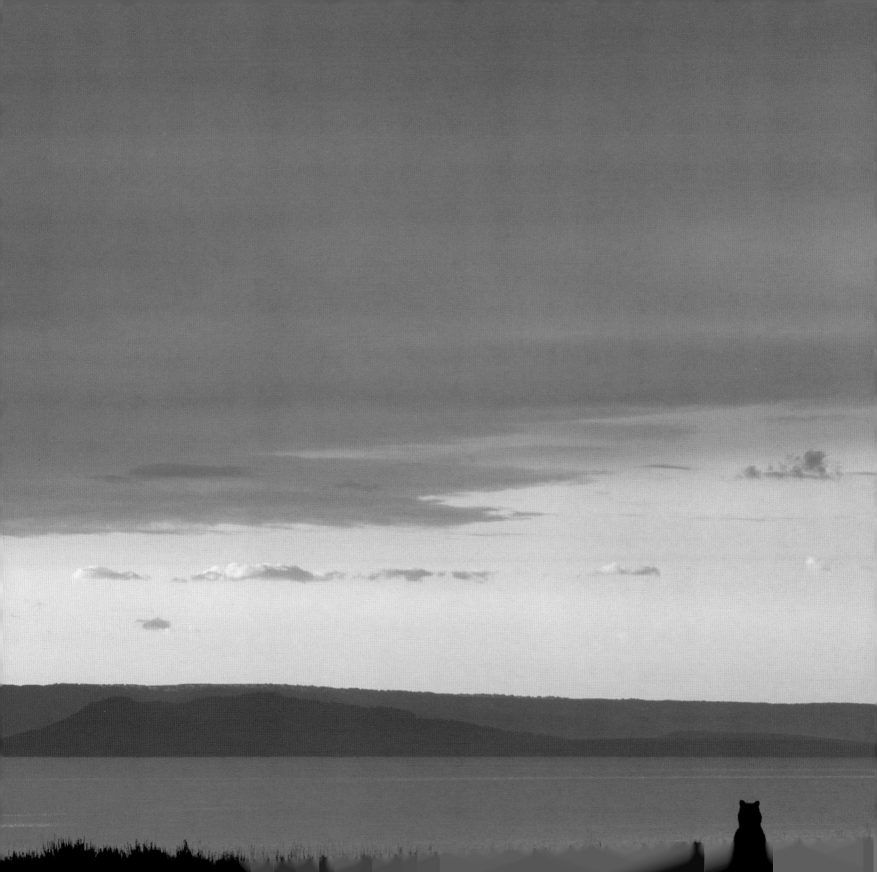

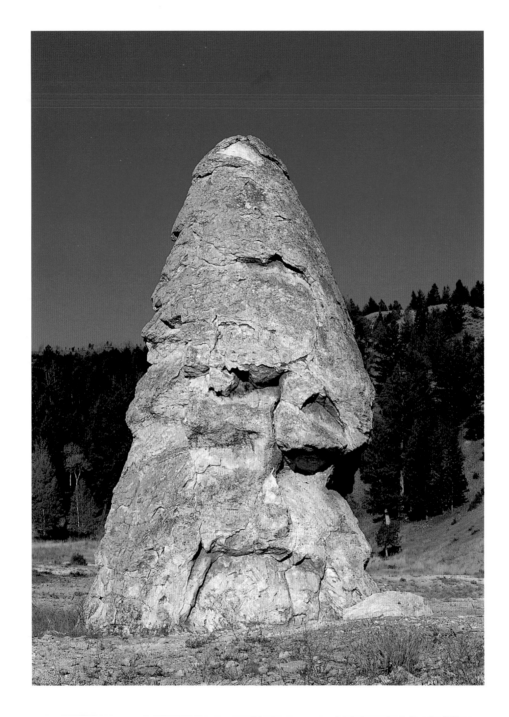

Above: Liberty Cap, which is located on the lower terrace of Mammoth Hot Springs, is a 37-foot cone from an extinct hot spring.

Facing page: In the Lamar Valley, the clear, blue waters of Rose Creek flow near the Yellowstone Institute, the Lamar Buffalo Ranch, and the Lamar ranger station.

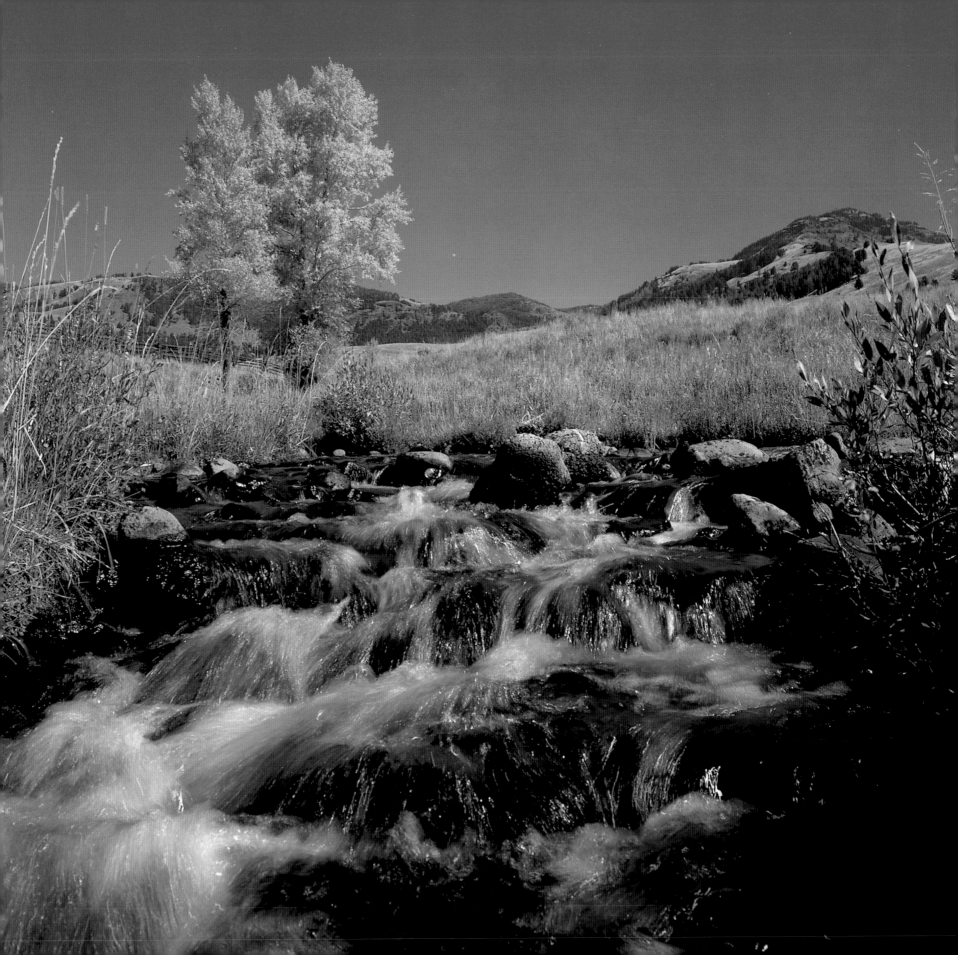

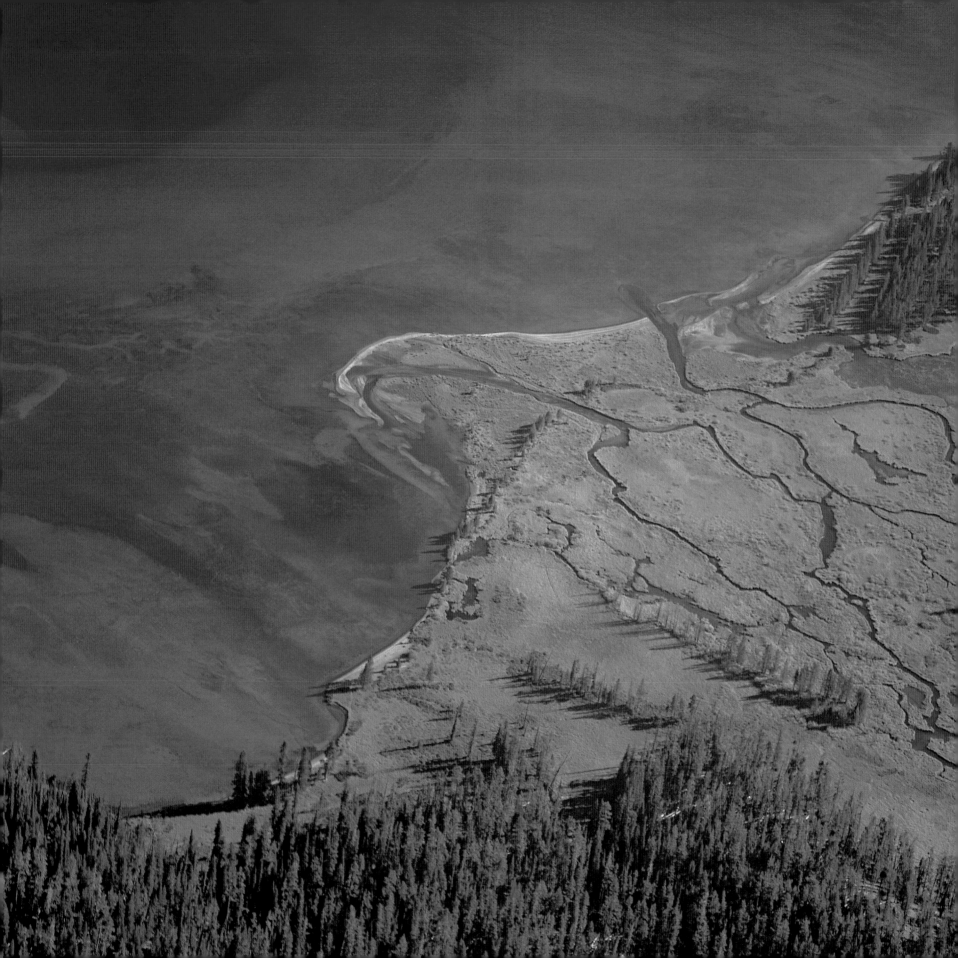

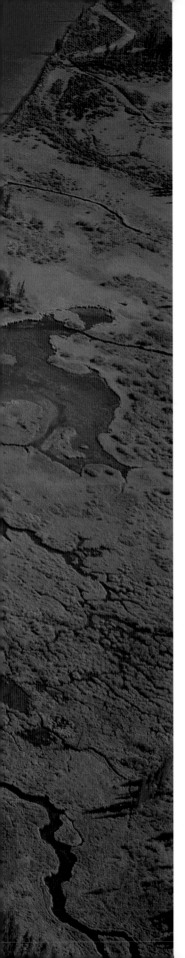

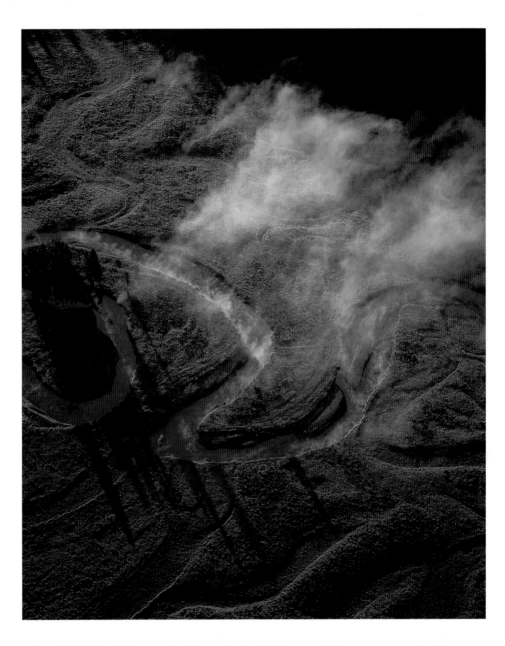

Above: The Pelican River snakes through the lush forests of the same-named valley, one of the nation's best habitats for grizzly bears, bison, elk, and other wildlife.

Left: An aerial view of the Delacy Creek Delta at Shoshone Lake.

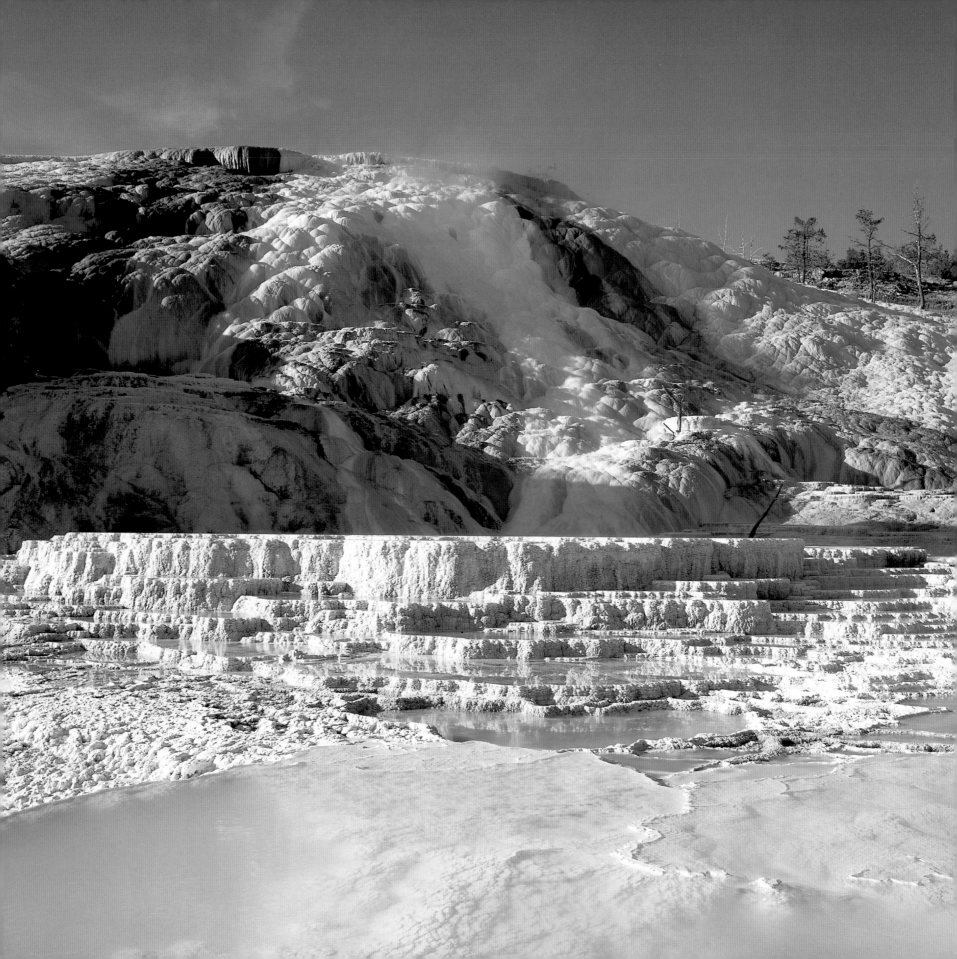

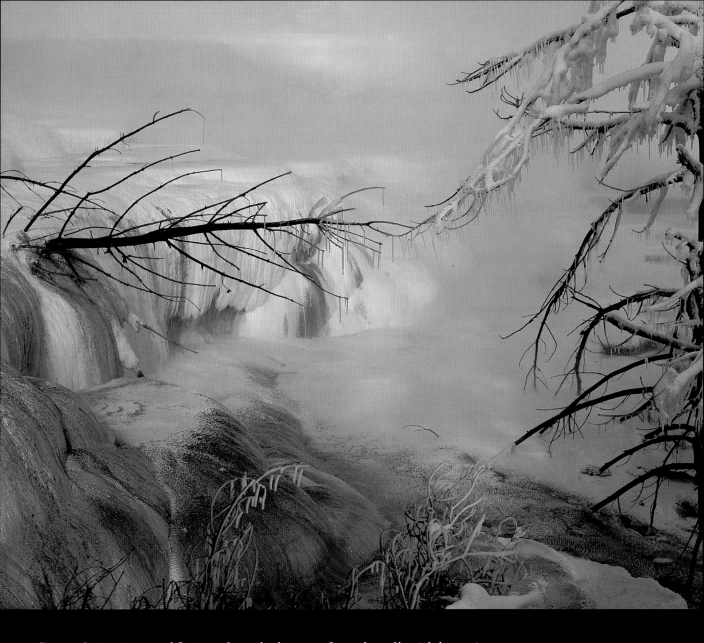

Above: Canary Spring is named for its color, which comes from the yellowish bacteria that thrive in the water.

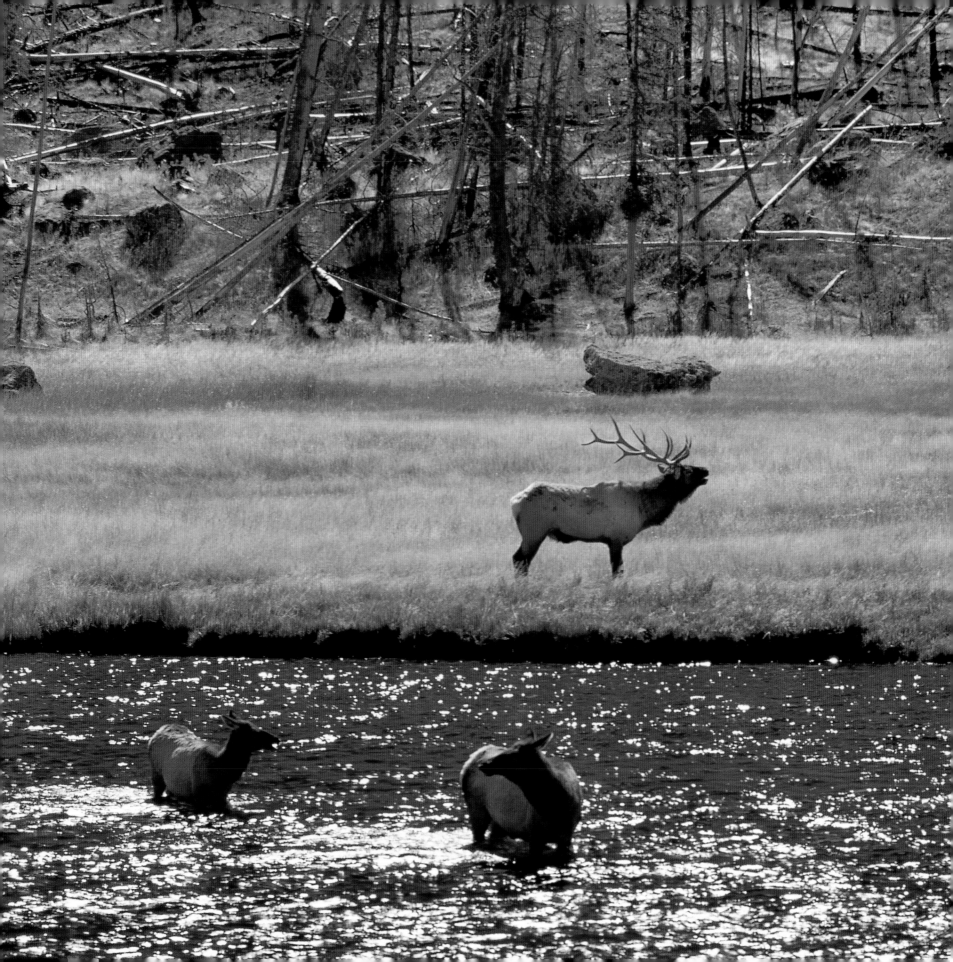

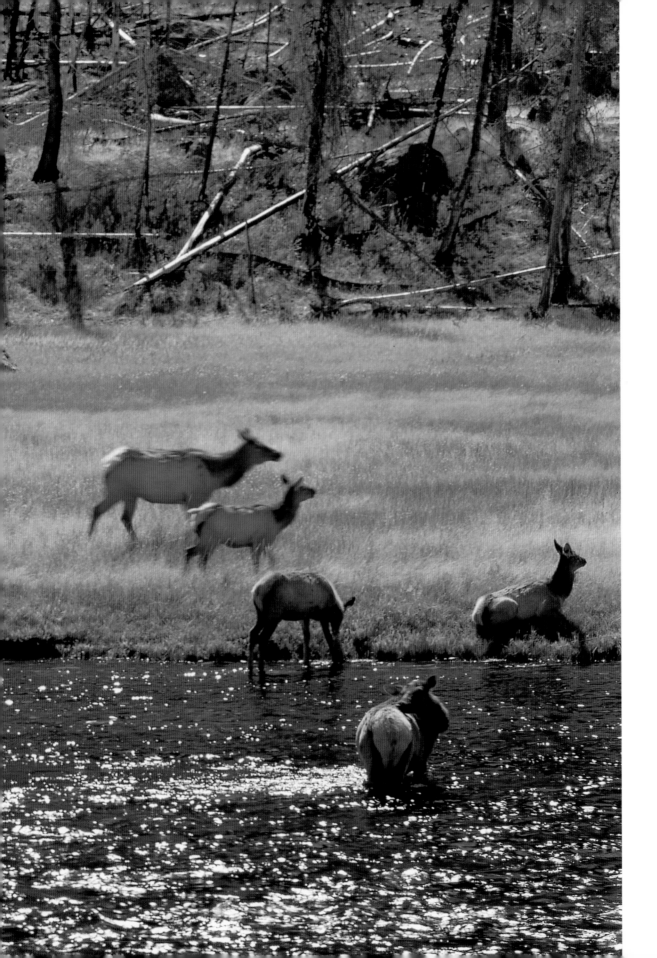

A bull elk and his harem gather on the golden-hued bank of the Madison River. Elk are the most abundant large mammals in the park.

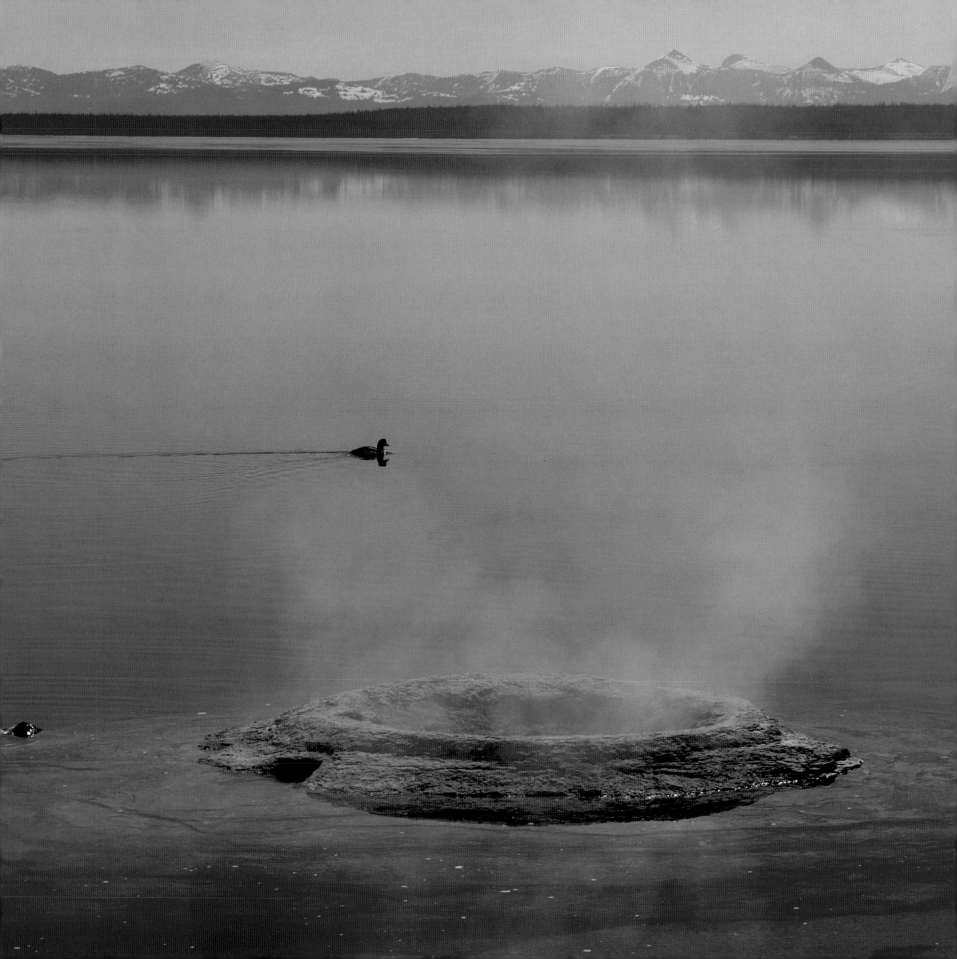

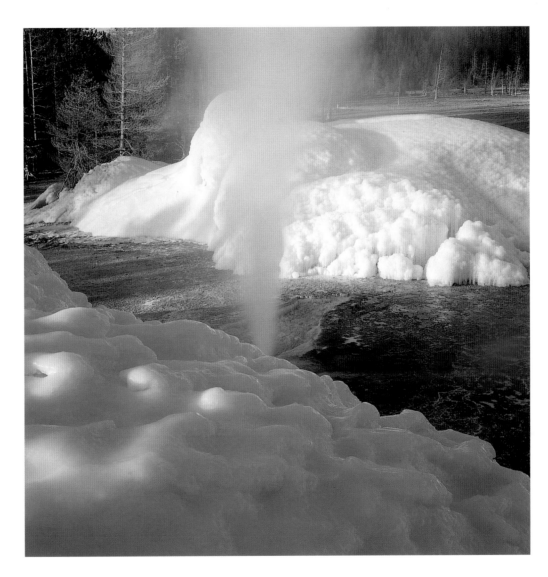

Above: Over the years, Porkchop Geyser has changed dramatically, with periods of activity and dormancy.

Left: Although fishing is no longer allowed there, the Fishing Cone on the shore of Yellowstone Lake got its name from early park visitors who fished the lake's waters and then dropped their catch—still on the line—into the vent to cook it.

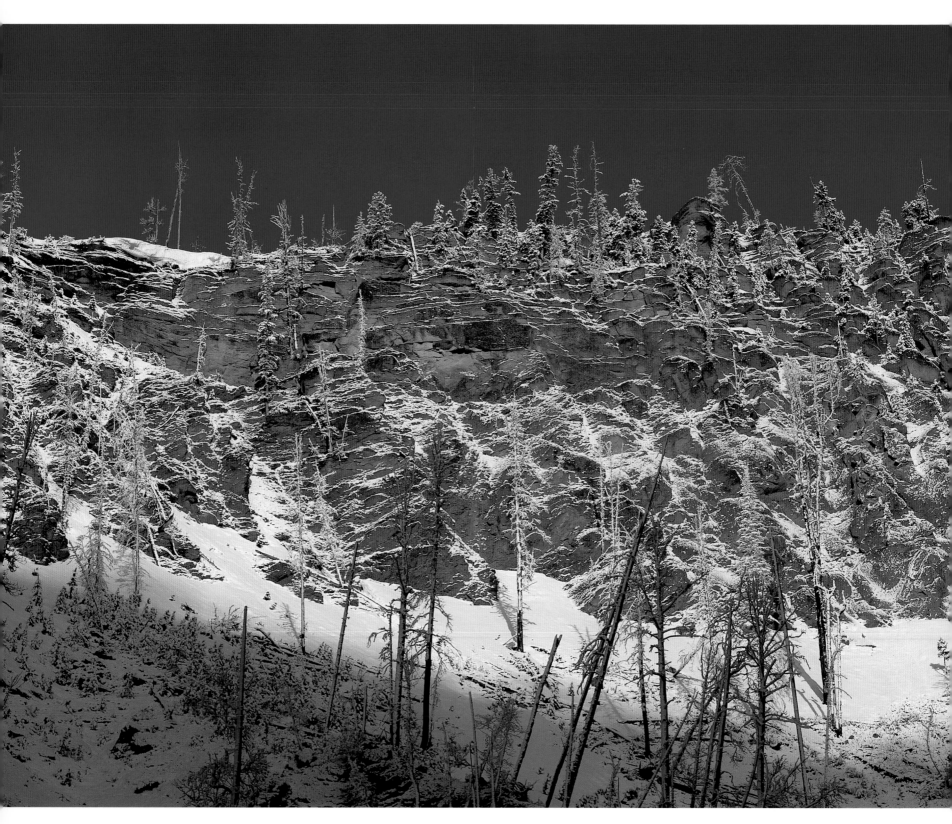

The red rhyolite cliffs along the Gibbon River, highlighted by snow,
form the western rim of the ancient Yellowstone caldera.

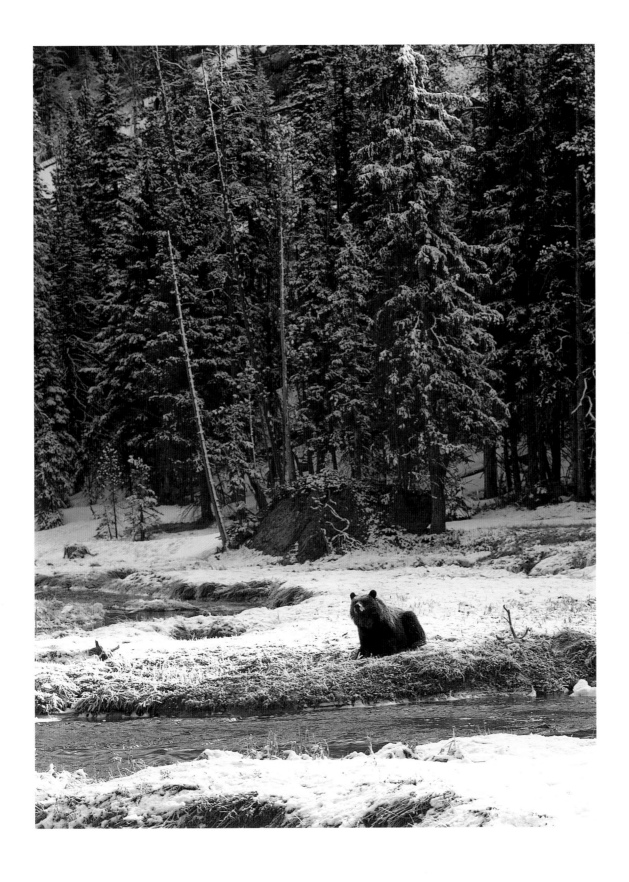

The dark shape of this
two-year-old grizzly
along Obsidian Creek
is easy to see in the
newly fallen snow.

Right: In the mud volcano area behind Sour Lake, a bison rests on the edge of the seething mud pot known as "the Gumper."

Below: The velvet rack of an elk appears above the grass at Madison Junction, where the Gibbon and Firehole Rivers form the headwaters of the Madison River.

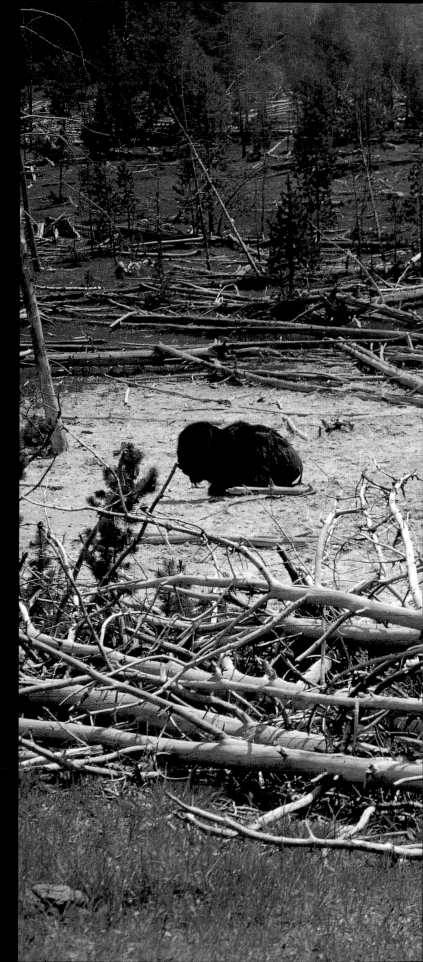

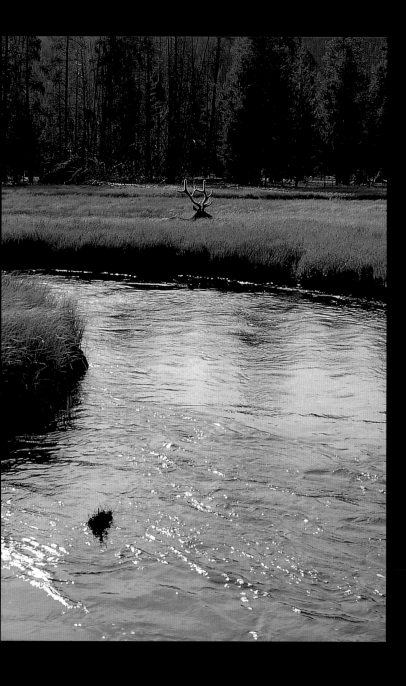

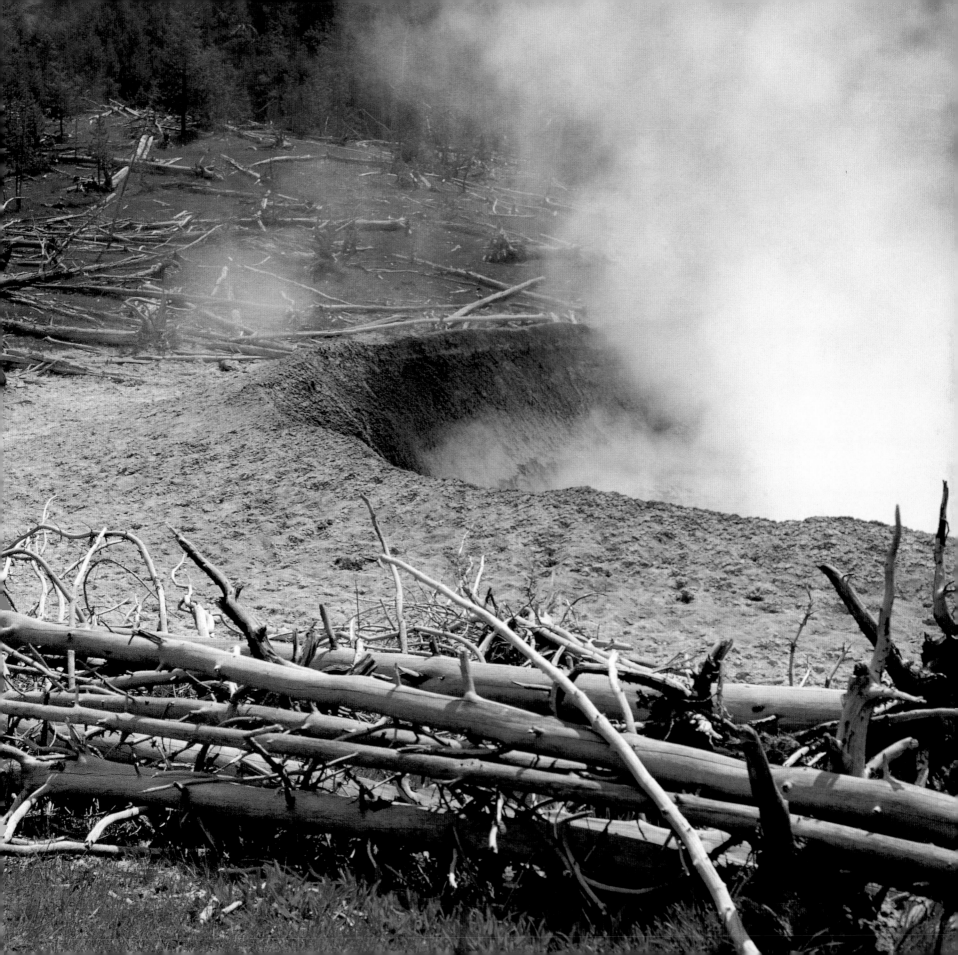

Right: Wildflowers thrive along the lush banks of Rabbit Creek.

Below: Witch Creek flows through Heart Lake Geyser Basin, a small, isolated basin at the foot of Mount Sheridan.

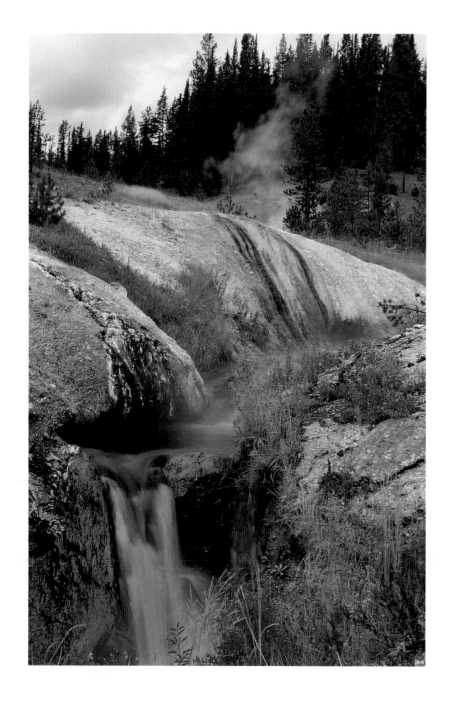

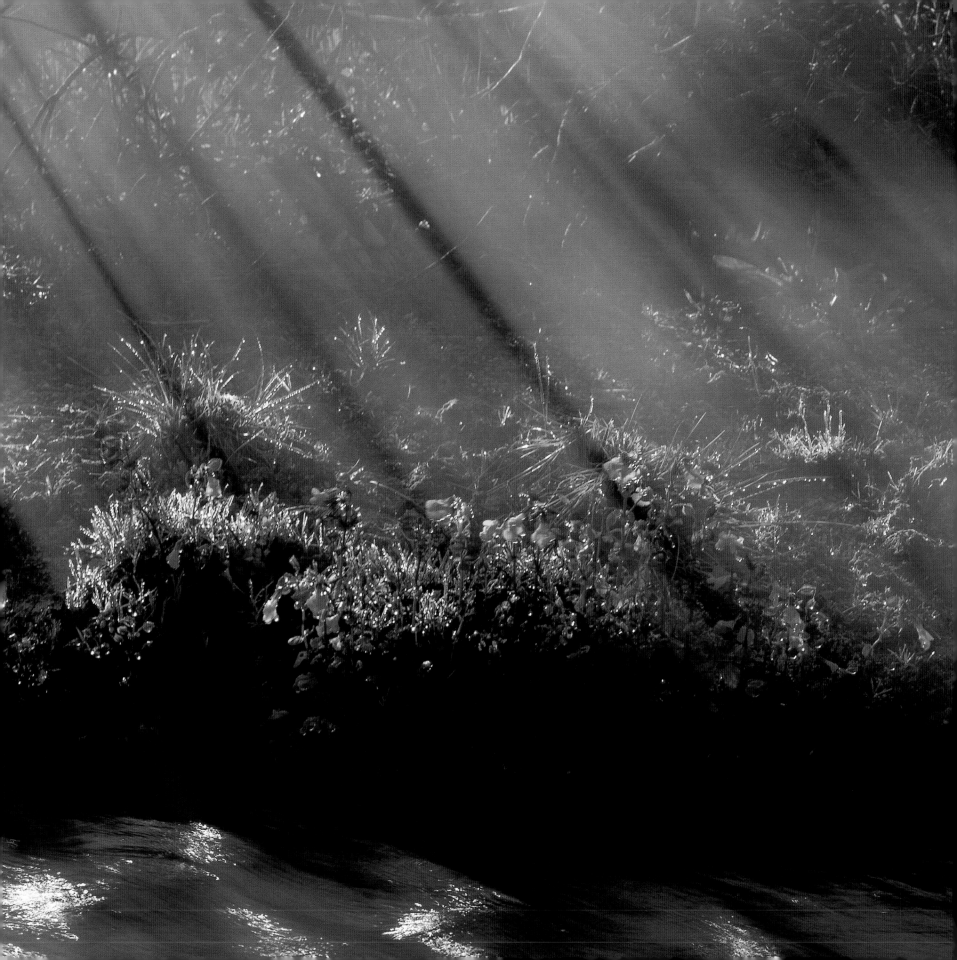

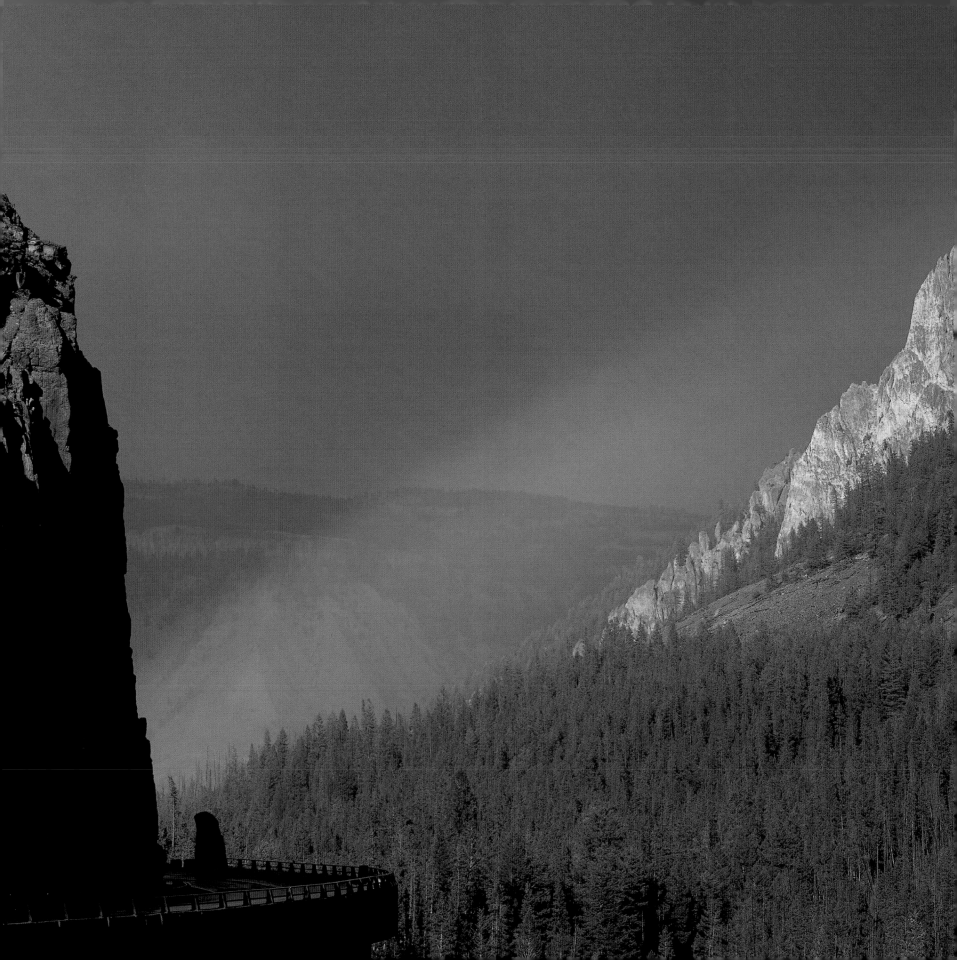

Left: A rainbow spans Golden Gate Canyon, near Mammoth Hot Springs along U.S. 89, which was named for the color of its rocks and the lichen that grows on them. The rock here is a product of the most massive Yellowstone volcanic eruption 2.1 million years ago.

Below: Devil's Slide, a vertical uplift known for its alternating layers of gray shale and russet iron, is located just outside the park near Gardiner, Montana.

Following page: The rising sun torches Barronette Peak, named for "Yellowstone Jack" Baronett, an early assistant superintendent of the park who built the first bridge over the Yellowstone River.

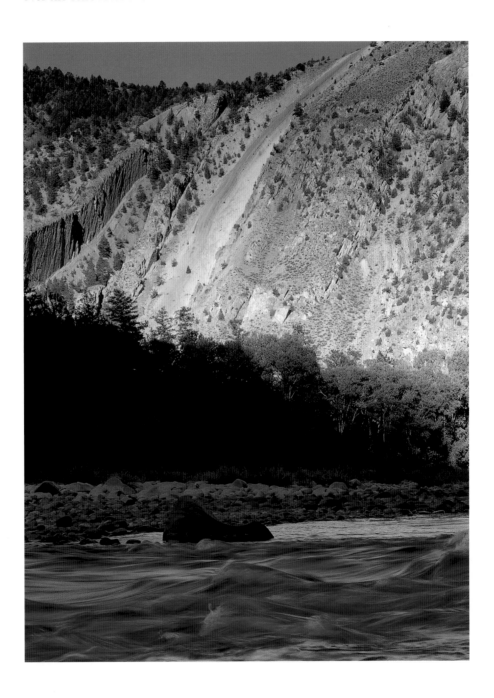

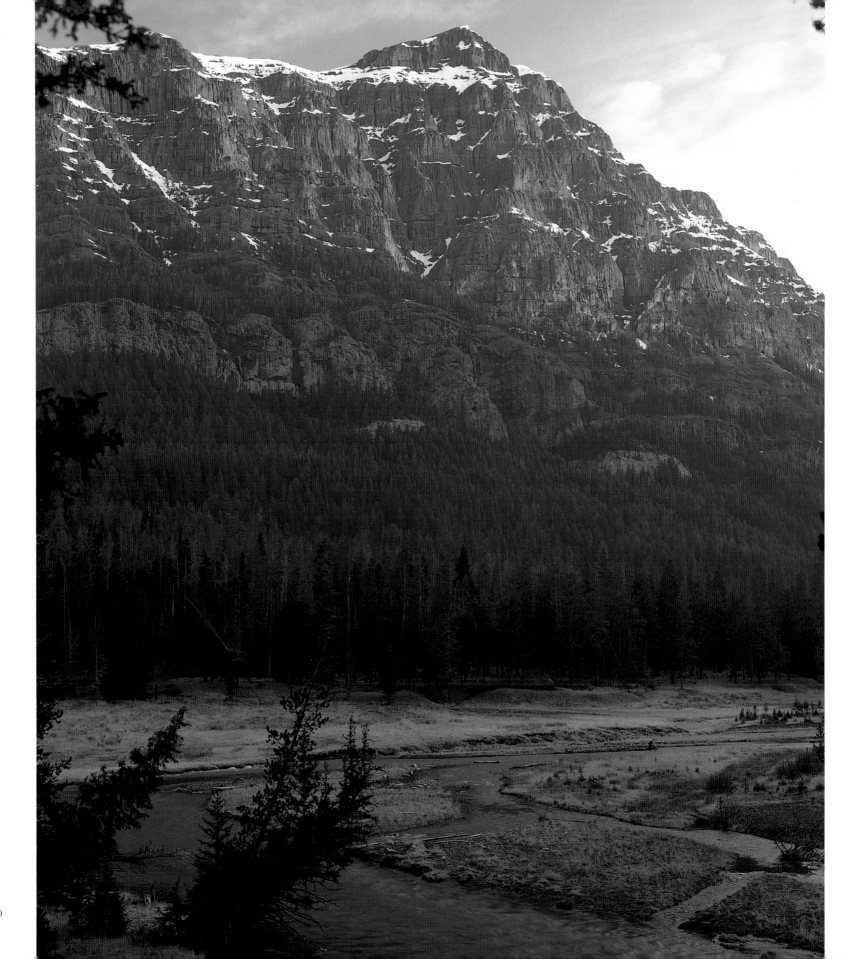